FASHION ILLUSTRATION TECHNIQUES

TECHNIQUES DU DESSIN DE MODE

TECHNIKEN DER MODEZEICHNUNG

FASHION ILLUSTRATION TECHNIQUES

TECHNIQUES DU DESSIN DE MODE

TECHNIKEN DER MODEZEICHNUNG

evergreen

© 2008 EVERGREEN GmbH, Köln

Editorial coordination:
Anja Llorella

Illustrations and texts:
Maite Lafuente

Editor:
Cristian Campos

English translation:
Chris Michalski

French translation:
Claire Debard

German translation:
André Höchemer

English proof-reading:
Mary Black

French proof-reading:
Valérie Lavoyer

German proof-reading:
Susanne Bonn

Art director:
Emma Termes Parera

Graphic design and layout:
Maira Purman

Printed in China

ISBN 978-3-8365-0407-2

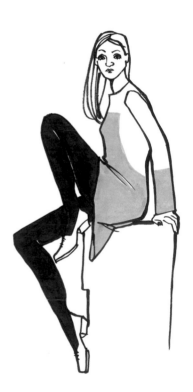

Introduction

At the beginning of the 20th century, it was generally held true within the fashion world that photography represented reality only imperfectly and was therefore inferior to painting and sculpture as an art form. From an artistic standpoint, depicting an article of clothing was only possible with a drawing. At best, photography was afforded second-class status. This was a strange opinion if we consider that at the time fashion illustration was limited to plain, unembellished reproductions of models and was more like illustrated photography. This would all change as soon as Paul Poiret entered the fashion scene.

Paul Poiret was the first designer to recognise the uses and vast potential of fashion illustration. His drawings rendered not so much the clothing itself as the emotions that it evoked, and in this way his works conveyed a kind of idealised view of the designs. Among Poiret's illustrators (George Barbiers, Georges Lepape, Paul Iribe and others), Erté stands out in particular. More than a simple, workaday fashion illustrator, Erté considered himself an artist. Fashion illustration in the first half of the 20th century was characterised by the techniques of engraving, watercolour, crayon and pastel.

In the course of the 1950s and 1960s, fashion illustration diminished in importance owing to the rising trend of fashion photography. Nevertheless, in the last three decades, such well-known illustrators as Antonio López, Mats Gustafson, René Gruau and Rubén Alterio have appeared in the most influential fashion publications alongside such star photographers as Mario Testino, Helmut Newton and Richard Avedon. In the 1970s and 1980s, felt-tip and ballpoint pens and even lead and coloured pencils were used predominately for fashion illustrations.

With today's widespread use of digital technology, fashion illustration is currently experiencing a kind of renaissance. With programs like Photoshop and Illustrator, digital compositions can be created that blur the boundaries between photography, drawing and painting. The technique of collage, which emerged with the rise of the avant-garde of the early 20th century, has been rediscovered by new fashion publications and now dominates the scene. With their redefinition of fashion and new style of fashion illustration, such magazines as *Nylon*, *Dazed and Confused*, *i-D* and *Purple* have begun challenging more traditional publications like *Vogue*, *Elle* and *Harper's Bazaar* in the competition for readers' approval.

Without a doubt, freehand drawing is the most fascinating element of every fashion illustration. Featuring numerous images and short, explanatory texts, this book offers a step-by-step introduction to the six most important techniques of fashion illustration: watercolour, crayon, pastel, felt-tip pens, pencils and collage. At the same time, the reader will be encouraged to experiment with these techniques on his or her own, and to combine them to create different effects and compositions.

This volume offers readers valuable information presented in an entertaining format, plus theoretical knowledge and practical tips, stirring in the passion that is essential in the fashion industry.

I believe all readers will find both passion and pleasure in this book.
Maite Lafuente

Introduction

Au début du XXe siècle, dans le monde de la mode, la photographie passait pour ne rendre la réalité que de manière imparfaite ; on la considérait donc comme une technique de moindre valeur que la peinture ou la sculpture. Sur le plan artistique, un vêtement pouvait uniquement être représenté sous la forme d'un dessin et la photographie tenait à la rigueur un rôle secondaire. Ce préjugé était d'autant plus singulier que les illustrations de mode de l'époque se limitaient à la reproduction exacte et fidèle d'un modèle, ce qui les rapprochait en fait de photographies dessinées. Les choses allaient changer brusquement avec l'entrée de Paul Poiret dans le monde de la mode.

Paul Poiret est le premier créateur à comprendre les avantages et les multiples possibilités de l'illustration de mode. Ses dessins représentent moins les vêtements que les émotions qu'ils suscitent et transmettent ainsi une vision idéalisée de l'esquisse. Parmi les illustrateurs avec lesquels Poiret travaille (George Barbiers, Georges Lepape, Paul Iribe et bien d'autres), c'est surtout Erté qui se distinguera. Il se voyait lui-même davantage comme un artiste que comme un simple illustrateur de mode salarié. Dans la première moitié du XXe siècle, l'illustration de mode était dominée par la gravure, l'aquarelle et les pastels, à l'huile ou secs.

Au cours des années 50 et 60, l'illustration de mode perd progressivement de son importance au profit de la nouvelle tendance, la photographie de mode. Malgré tout, des illustrateurs de renom, comme Antonio López, Mats Gustafson, René Gruau et Rubén Alterio, parviennent à s'imposer face à des stars de la photographie tels que Mario Testino, Helmut Newton ou Richard Avedon dans les principaux magazines de mode au cours des trois dernières décennies du siècle. Dans les années 70 et 80, ce sont surtout le crayon feutre, le stylo à bille ou même le crayon, à papier ou de couleur, qui dominent l'illustration de mode.

L'illustration de mode connaît une renaissance aujourd'hui, avec la diffusion des techniques numériques. Des programmes comme Photoshop ou Illustrator permettent de réaliser des compositions numériques qui font définitivement tomber les frontières entre photographie, dessin et peinture. Le collage, apparu au début du XXe siècle avec les mouvements artistiques d'avant-garde, est redécouvert par les magazines récents qu'il marque de sa griffe. Des revues comme *Nylon*, *Dazed and Confused*, *i-D* ou *Purple* sont, avec leur redéfinition de la mode et le style d'illustration inédit dont elle s'accompagne, parties à la conquête des lecteurs de publications traditionnelles telles que *Vogue*, *Elle* et *Harper's Bazaar*.

C'est sans aucun doute la liberté du dessin qui fait le véritable charme d'une image. Notre ouvrage propose, à l'aide de nombreuses illustrations et de courts textes explicatifs, une introduction pas à pas aux six principales techniques de l'illustration de mode : l'aquarelle, les pastels à l'huile, les pastels secs, le crayon-feutre et les crayons à papier ou de couleur, sans oublier le collage. En même temps, le lecteur est incité à aborder ces techniques de manière décontractée, à les associer les unes aux autres et à s'y essayer.

Cet ouvrage, qui présente au lecteur des exemples intéressants, offre également un divertissement théorique et pratique, susceptible d'éveiller la passion, moteur essentiel de la mode.

Je vous souhaite donc une lecture passionnée.
Maite Lafuente

Zu Beginn des 20. Jahrhunderts galt die Fotografie in der Modewelt als eine Technik, die die Realität nur unvollkommen abbildete, und daher als eine der Malerei oder Bildhauerei nicht ebenbürtige Kunstform. Die Darstellung eines Kleidungsstücks war in künstlerischer Hinsicht ausschließlich in Form einer Zeichnung möglich, die Fotografie besaß bestenfalls den Status der Zweitrangigkeit. Ein eigenartiges Vorurteil, wenn man bedenkt, dass sich die Modeillustrationen jener Zeit auf eine schlichte, undifferenzierte Wiedergabe eines Modells beschränkten und so eher gezeichneten Fotografien glichen. Dies sollte sich abrupt ändern, als Paul Poiret in die Modewelt trat.

Paul Poiret erkannte als erster Designer den Nutzen und die vielfältigen Möglichkeiten, die die Modeillustration bot. Seine Zeichnungen stellten weniger die Kleidung selbst dar als vielmehr die Emotionen, die sie auslösten, und vermittelten so eine idealisierte Sichtweise der Entwürfe. Unter Poirets Illustratoren (George Barbiers, Georges Lepape, Paul Iribe und andere) stach besonders Erté hervor, der sich selbst eher als Künstler denn als einfachen, lohnabhängigen Modeillustrator verstand.

Die Modeillustrationen in der ersten Hälfte des vergangenen Jahrhunderts waren geprägt von Stichen, Aquarell-, Wachs- und Pastellmalerei. Die Modeillustration verlor während der 1950er und 1960er Jahre durch den einsetzenden Trend hin zur Modefotografie zunehmend an Bedeutung. Bekannte Illustratoren wie Antonio López, Mats Gustafson, René Gruau und Rubén Alterio haben dennoch in den letzten drei Jahrzehnten ihren Platz in den wichtigsten Modezeitschriften neben Starfotografen wie Mario Testino, Helmut Newton oder Richard Avedon behaupten können. In den 1970er und 1980er Jahren dominierten vor allem Faserstift, Kugelschreiber und sogar Blei- und Buntstift den Stil der Modeabbildungen.

Gegenwärtig erlebt die Modeillustration mit der Verbreitung digitaler Techniken eine Renaissance. Programme wie Photoshop oder Illustrator ermöglichen digitale Kompositionen, die die Grenzen zwischen Fotografie, Zeichnung und Malerei endgültig verwischen. Die Collage, die mit den avantgardistischen Kunstströmungen zu Beginn des 20. Jahrhunderts aufkam, wurde von den jungen Modezeitschriften neu entdeckt und prägt deren Erscheinungsbild. Magazine wie *Nylon*, *Dazed and Confused*, *i-D* oder *Purple* haben mit ihrer Redefintion von Mode und einem damit einhergehenden neuen Stil in der Modeillustration traditionellen Publikationen wie *Vogue*, *Elle* und *Harper's Bazaar* den Wettstreit um die Gunst der Leser angesagt.

Freies Zeichnen macht ohne jeden Zweifel den wahren Reiz einer jeden Illustration aus. Dieses Buch führt mit zahlreichen Abbildungen und erklärenden, kurzen Texten Schritt für Schritt in die sechs wichtigsten Techniken der Modeillustration ein: die Aquarell-, Wachs- und Pastellmalerei, das Zeichnen mit Faserstift und Blei-/Buntstift sowie die Collagetechnik. Gleichzeitig soll der Leser angeregt werden, sich spielerisch mit diesen Techniken zu befassen, sie miteinander zu kombinieren und mit ihnen zu experimentieren.

Dieser Band bietet dem Leser Wissenswertes neben Unterhaltsamem, Theoretisches neben Praktischem und soll in ihm die in der Modebranche unverzichtbare Leidenschaft entfachen.

Ich wünsche Ihnen ein leidenschaftliches Vergnügen.
Maite Lafuente

WATERCOLOURS

LES AQUARELLES / AQUARELLFARBEN

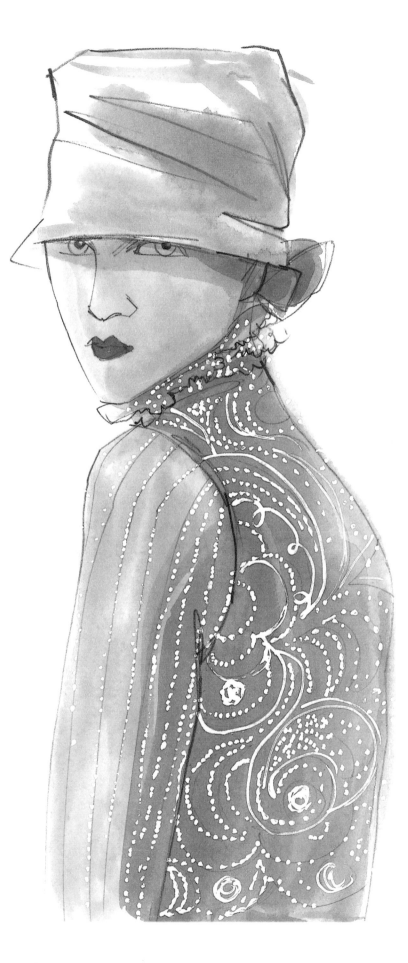

Watercolours lend themselves superbly to the depiction of transparency and glittering decoration. For this dress in the style of the 1930s, the transparent material – conveyed in gouache – was adorned with dazzling sequins. Zinc white brings out the brilliance of the sequins very well.

L'aquarelle se prête parfaitement à la représentation des transparences et des bijoux. Sur cette robe dans le style du premier tiers du XXe siècle, l'étoffe transparente peinte à la gouache est ornée de paillettes scintillantes. Le brillant peut aussi être rendu avec du blanc de zinc.

Aquarellfarben eignen sich hervorragend zur Darstellung von Transparenz und Juwelenschmuck. Bei diesem Kleid im Stile des ersten Drittels des 20. Jahrhunderts wurde der transparente Stoff in Gouache-Malerei mit schillernden Pailletten verziert. Glanz lässt sich auch gut mit Zinkweiß darstellen.

The particular watercolour paper should be strong, but should not have too heavy a grain.
The use of high-quality brushes is recommended, for example, of ox-ear-, camel- or marten hair.
Brush-like felt-tip pens are best suited to monochrome drawings.

Le papier pour aquarelle doit être solide, mais d'un grain moyen .
Choisir de préférence des pinceaux de qualité supérieure, par exemple en poils d'oreille de bœuf, de chameau ou de martre.
Pour les dessins monochromes, mieux vaut des feutres pinceaux.

Das spezielle Aquarellpapier sollte kräftig sein, jedoch keine allzu starke Maserung aufweisen.
Empfehlenswert ist die Verwendung hochwertiger Pinsel, beispielsweise aus Rindsohr-, Kamel- oder Marderhaar.
Für einfarbige Zeichnungen eignen sich pinselähnliche Filzstifte am besten.

There is a large selection of different types of watercolours on the market, such as watercolour pens, aniline colours, and in bottles or tubes.

On trouve dans le commerce un grand choix de couleurs pour aquarelle, ainsi que des crayons-aquarelle, des couleurs à l'aniline, des blocs et des peintures en flacon ou en tube.

Im Handel gibt es eine große Auswahl an verschiedenen Aquarellfarben wie zum Beispiel Aquarellstifte, Anilinfarben, Blöcke sowie Farben in Gläschen oder Tuben.

WATERCOLOURS Application / AQUARELLE Technique / AQUARELLFARBEN Anwendung

Keep in mind that watercolours dry very quickly.
Toujours penser que l'aquarelle sèche très vite.
Bedenken Sie, dass Aquarellfarbe sehr schnell trocknet.

1. First sketch the outlines lightly so that you can erase them later.
2. Then wet the paper with some water.
1. Commencer par dessiner les contours d'un trait fin afin de pouvoir les gommer plus tard.
2. Humidifier légèrement le papier.
1. Zunächst zeichnet man die Konturen zart vor, um sie später wieder ausradieren zu können.
2. Anschließend benetzt man das Papier mit etwas Wasser.

3. Start with the lighter colours. For people, this is usually the skin, but it can also be a pastel-coloured or an almost-white article of clothing.
3. Commencer par les couleurs les plus claires. Pour les personnages, c'est souvent la peau, mais cela peut aussi être un vêtement de couleur pastel ou presque blanc.
3. Fangen Sie mit den helleren Farben an. Bei Personen ist dies zumeist die Haut; es kann aber auch ein pastellfarbenes bzw. nahezu weißes Kleidungsstück sein.

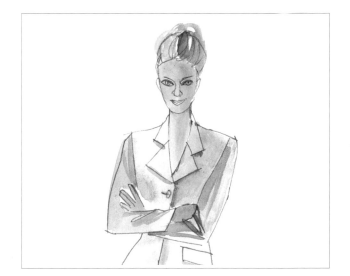

4. Next apply the middle tones, for example, the base tone of the material.
4. Appliquer ensuite les tons moyens, par exemple le fond d'un tissu.
4. Dann werden die mittleren Farbtöne aufgetragen, beispielsweise der Grundton des Stoffs.

5. Finally, add the darker, more striking colours, which are usually used for creating fabric patterns, shadows and folds.
5. Finir avec les teintes les plus sombres et les plus vives ; elles sont souvent utilisées pour les motifs d'un tissu, les ombres ou les plis.
5. Zuletzt malt man dunklere, markantere Farben, die gewöhnlich zur Gestaltung von Stoffmustern, Schatten und Falten dienen.

The hats from the early 20th century illustrated here are each painted as a monochrome watercolour on coarse-grained paper. If the eye is to be directed to the specific shape of the clothing, this should be depicted in a single colour with particular emphasis on contours.

Ces chapeaux du début du XXe siècle ont été peints à l'aquarelle unie sur du papier rugueux. Pour attirer l'attention sur la forme, les volumes sont laissés unis et les contours particulièrement accentués.

Die hier abgebildeten Hüte aus dem frühen 20. Jahrhundert sind jeweils als einfarbiges Aquarell auf rauem Papier gemalt. Soll der Blick des Betrachters gezielt auf die Form gelenkt werden, wird das Volumen einfarbig und mit besonderer Betonung der Konturen gestaltet.

All decorative elements on clothing, such as feathers, furs or embroidery, are shown to better advantage if they are painted in a single colour. Using this technique, the shape of an article of clothing, as well as its decorative accessories, can be accentuated.

Les ornements des vêtements, plumes, fourrure ou broderies, sont mis plus en valeur s'ils sont peints unis. Une astuce qui permet de souligner, outre les accessoires décoratifs, le volume ou l'ampleur d'un vêtement.

Alle Schmuckelemente an Kleidungsstücken sowie Federn, Pelze oder Stickereien kommen stärker zur Geltung, wenn sie einfarbig gemalt werden. Mit diesem Kniff kann neben schmückenden Accessoires auch das Volumen eines Kleidungsstücks hervorgehoben werden.

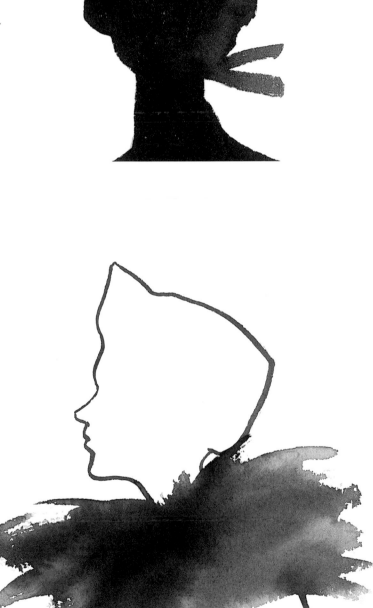

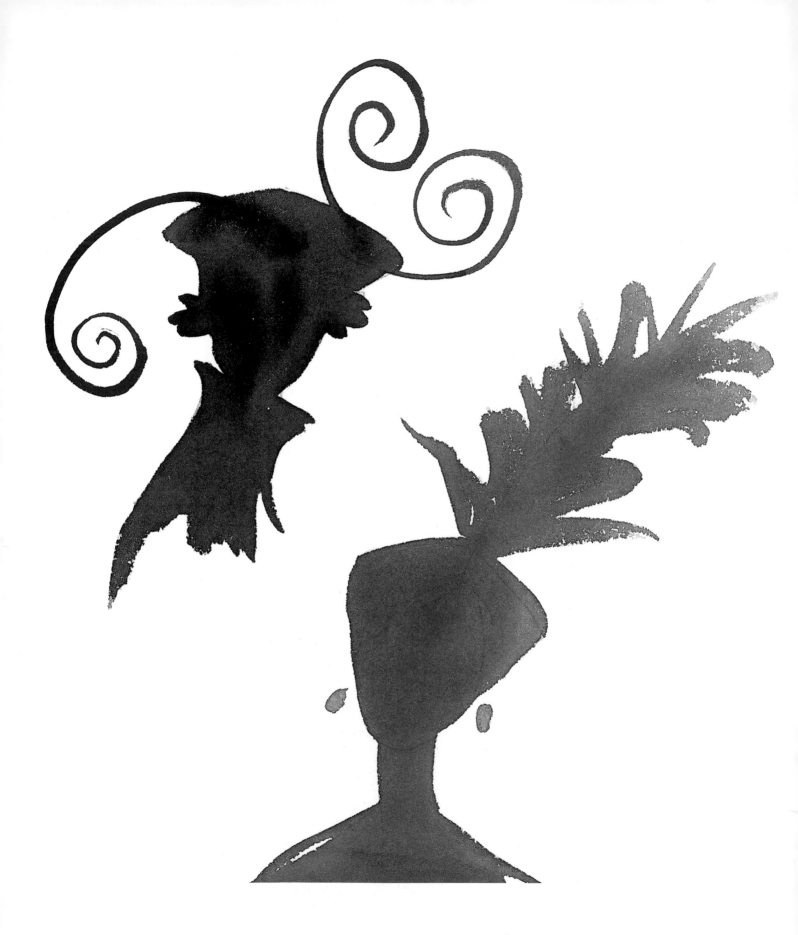

At the beginning of the 20th century, magnificent, flamboyant hats were frequently worn. The decorative feathers and the weight of the hats due to the materials used obliged women to wear high, tight collars in order to keep their necks straight.

Au début du XXe siècle, les chapeaux étaient souvent somptueux et surchargés. Les plumes et le poids des matériaux utilisés obligeaient les femmes à porter des collerettes pour pouvoir garder la tête droite.

Zu Beginn des 20. Jahrhunderts wurden häufig prunkvolle, überladene Hüte getragen. Der Federschmuck und das Gewicht der Hüte durch die verwendeten Materialien zwangen die Frauen, Halskrausen zu tragen, um den Hals gerade halten zu können.

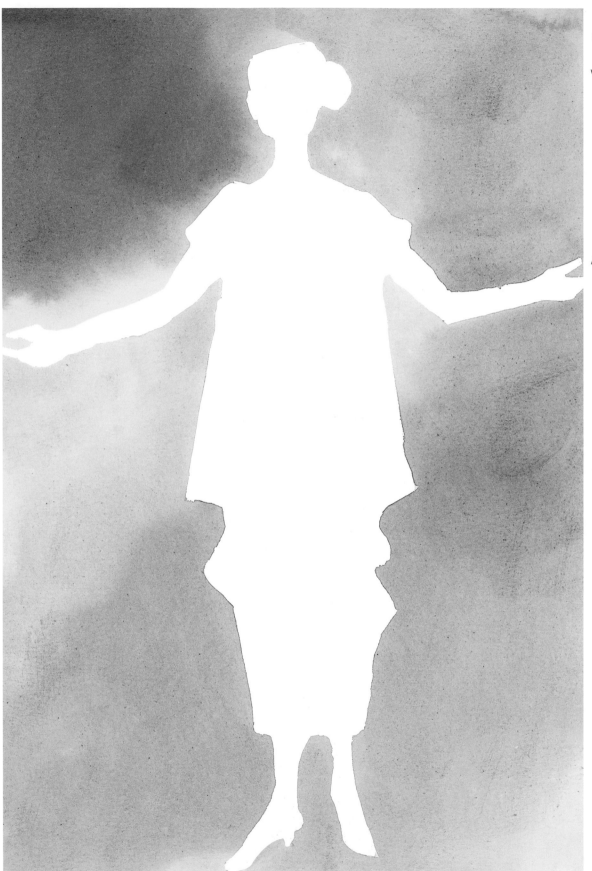

In this illustration, the background has been painted with heavily diluted watercolours and the figure left in white. In order to achieve the sharply defined contours, masking fluid is first applied with a damp brush to the areas to be left white. As soon as it is dry, the background is painted and the masking layer peeled off with the fingers.

Le fond a été peint ici à l'aquarelle très diluée et le personnage laissé en blanc. Pour des contours précis, commencer par appliquer une couche de liquide à masquer avec un pinceau humide sur la surface à réserver et dès qu'elle est sèche, peindre le fond avant d'effacer la couche masquée avec les doigts.

In dieser Illustration wurde der Hintergrund mit stark verdünnten Aquarellfarben gemalt und die Figur weiß ausgespart. Damit die Konturen scharf herausgearbeitet werden können, wird zunächst mit einem feuchten Pinsel Maskierflüssigkeit auf die auszusparenden Flächen aufgetragen. Sobald sie getrocknet ist, wird der Hintergrund gemalt und dann die Maskierschicht mit den Fingern abgezogen.

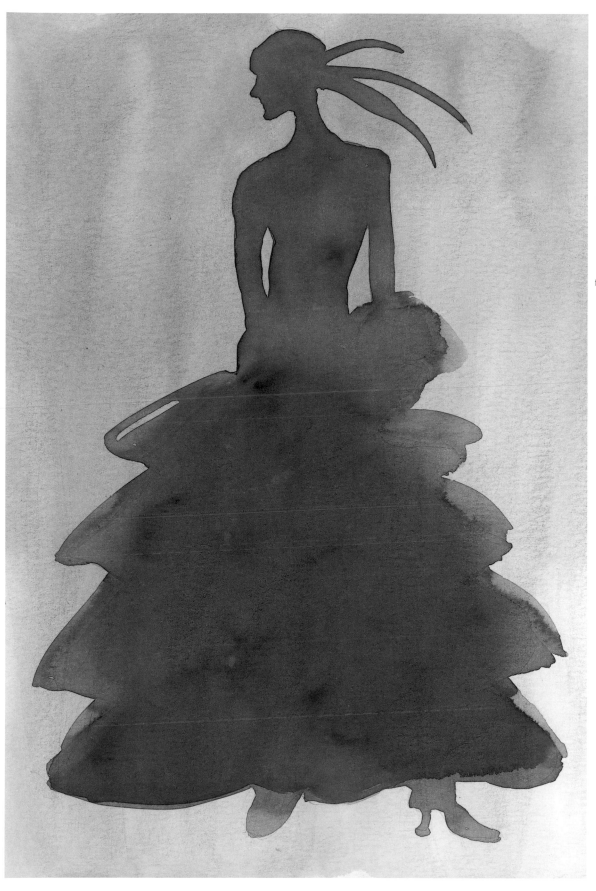

In order to emphasise certain areas and to depict volume, one can use several variations of the one watercolour, which can be achieved by either heavily diluting the paint or with colour shading (the camaïeu technique). The combination of turban and feathers was typical of the Golden Twenties.

Pour souligner certaines surfaces et représenter des volumes, on utilise différents tons d'une même couleur, obtenus en diluant plus ou moins l'aquarelle, ou un dégradé de couleurs (camaïeu). L'association d'un turban et de plumes est typique des années folles.

Um bestimmte Flächen hervorzuheben und Volumen darzustellen, verwendet man verschiedene Varianten ein und derselben Aquarellfarbe, die man durch unterschiedlich starke Verdünnung oder farbliche Abstufung (Camaïeu) erzielt. Die Kombination aus Turban und Federn war typisch für die goldenen 1920er Jahre.

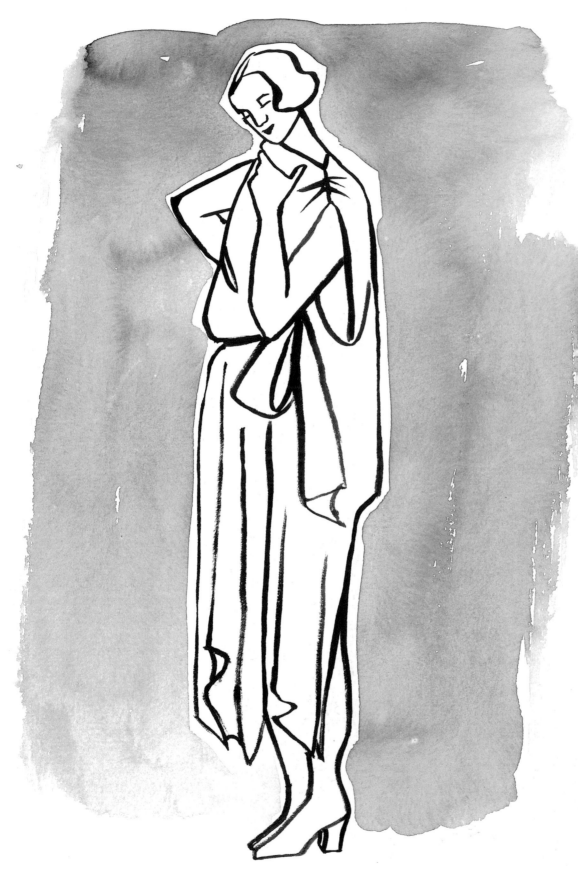

This figure, which appears as both a positive and a negative image, features drapery by Madeleine Vionnet, the inventor of the bias cut. Lightly sketch in pencil so that you can later erase these contours and fill them out with barely moistened colour. The background should be painted in diluted watercolours.

En positif et en négatif, une esquisse de plissé de Madeleine Vionnet, l'inventrice de la coupe en biais. Le personnage est d'abord dessiné d'un fin trait de crayon à papier pour pouvoir ensuite en gommer les contours et les reprendre à la technique sèche. Le fond est peint à l'aquarelle diluée.

Diese einmal positiv und dann negativ dargestellte Figur zeigt Faltenwürfe von Madeleine Vionnet, der Erfinderin des Diagonalschnitts. Die Figur wird mit Bleistift zart vorgezeichnet, um diese Konturen später ausradieren zu können, und mit kaum angefeuchteter Farbe nachgezogen. Der Hintergrund wird mit verdünnter Aquarellfarbe gemalt.

The same figure was executed here with masking fluid following the steps previously outlined. The masking fluid acts as a screen and allows one to work more freely as it prevents colour from encroaching on the covered areas.

Le même motif a été réalisé avec du liquide à masquer comme décrit plus haut. Le liquide à masquer forme un modèle et permet un travail plus libre car il empêche la couleur de recouvrir les surfaces masquées.

Dieselbe Figur wurde hier mit Maskierflüssigkeit nach den zuvor genannten Schritten ausgeführt. Die Maskierflüssigkeit dient als Schablone und ermöglicht ein freies, ungehemmtes Arbeiten, da sie verhindert, dass Farbe auf die abgedeckten Stellen gelangt.

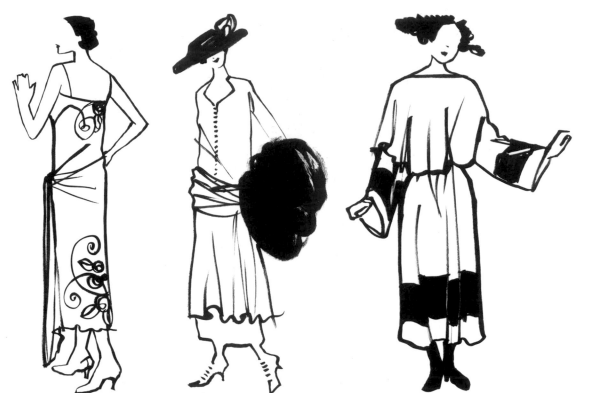

A good exercise is to copy the volumes of the following designs by Paul Poiret and Chanel in simple, delicate drawings using a single colour and barely diluted paint. Details such as fabrics, folds, draping, furs, patterns, embroidery or accessories can then be emphasised.

Un bon exercice : reproduire le volume de ces ébauches de Paul Poiret et Chanel sur des esquisses simples, fines et unies avec des couleurs très peu diluées. Cela permet de souligner des détails tels que tissus, fronces, plissés, fourrures, motifs, broderies ou accessoires.

Eine gute Übung ist es, das Volumen der folgenden Entwürfe von Paul Poiret und Chanel in einfachen, zarten Skizzen und einfarbiger Gestaltung mit kaum verdünnter Farbe nachzuzeichnen. So lassen sich Details, wie Stoffe, Falten, Faltenwürfe, Pelze, Muster, Stickereien oder Accessoires, betonen.

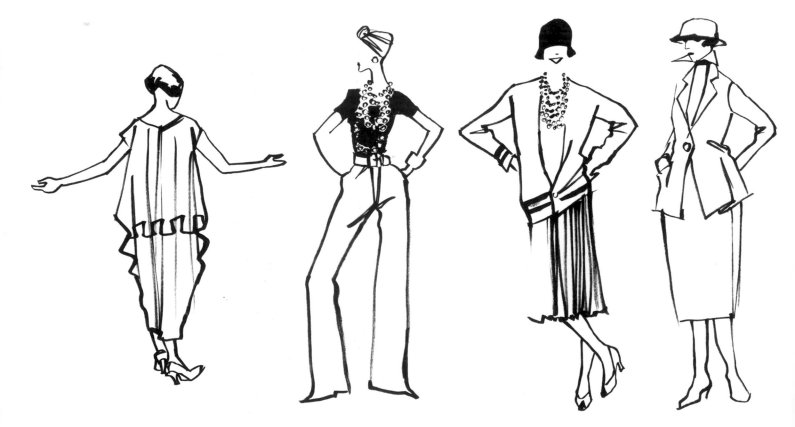

Here three different options for
illustrating Poiret's designs are shown:
1. Thin black outlines in very dry
watercolour.
2. A translucent pencil sketch and
heavily diluted neutral shades applied
two-dimensionally.
3. A similar representation to that in
picture 2, but with luminescent
watercolours.

Trois possibilités différentes d'illustrer
les esquisses de Poiret :
1. En noir avec un tracé précis et une
aquarelle très sèche.
2. Un dessin au crayon visible par
transparence et des tons neutres très
dilués sur toute la surface.
3. Comme l'illustration précédente mais
avec des aquarelles de couleurs vives.

Dieses Bild zeigt drei verschiedene
Möglichkeiten, die Entwürfe von Poiret
zu illustrieren:
1. Schwarze Farbe und eine knappe
Linienführung mit sehr trockener
Aquarellfarbe.
2. Eine durchscheinende
Bleistiftzeichnung und stark verdünnte,
flächig aufgetragene Farben in neutralen
Tönen.
3. Eine ähnliche Gestaltung wie in
Abbildung 2, jedoch mit leuchtenden
Aquarellfarben.

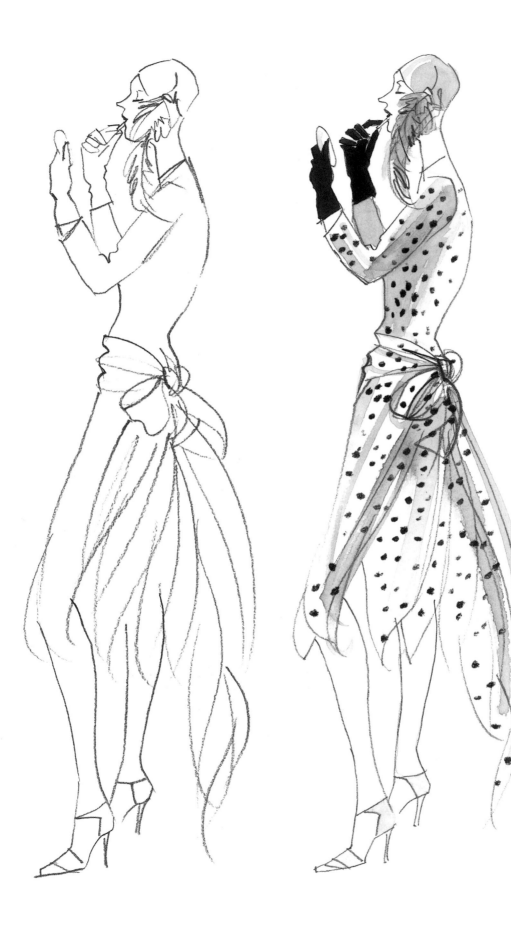

For this illustration, the figure is first sketched in pencil. Then you indicate the background colour of the dress; depending on how the light falls, apply the colour more delicately or vigorously, as appropriate. As soon as the watercolour is dry, the dress pattern or embroidery can be added.

Ce personnage commence par être dessiné au crayon. Le fond de la robe est ensuite peint d'une couleur plus pâle ou plus vive selon l'éclairage. Dès que l'aquarelle est sèche, la robe est ornée de motifs ou de broderies.

Bei diesem Bild wird die Figur zunächst mit Bleistift vorgezeichnet. Anschließend deutet man die Grundfarbe des Kleids an, je nach Lichteinfall mit zarterem oder kräftigerem Farbauftrag. Sobald das Aquarell trocken ist, wird das Kleid mit dem Muster oder der Stickerei verziert.

One of the most frequently used techniques to direct the onlooker's gaze to a particular place is graduating and/or blending colour to white. In the Twenties, silk robes came into fashion which were extremely pleasant to wear and allowed great freedom of movement.

Le dégradé de couleurs ou l'éclaircissement progressif des couleurs est une astuce souvent utilisée pour attirer l'œil vers un endroit précis. Les années 20 ont vu apparaître des robes en soie, qui étaient extrêmement agréables à porter et laissaient une grande liberté de mouvements.

Einer der häufigsten Kniffe, um den Blick des Betrachters auf eine bestimmte Stelle zu lenken, ist die Farbabstufung bzw. der Farbverlauf hin zu Weiß. In den 1920er Jahren kamen seidene Gewänder auf, die äußerst angenehm zu tragen waren und eine große Bewegungsfreiheit boten.

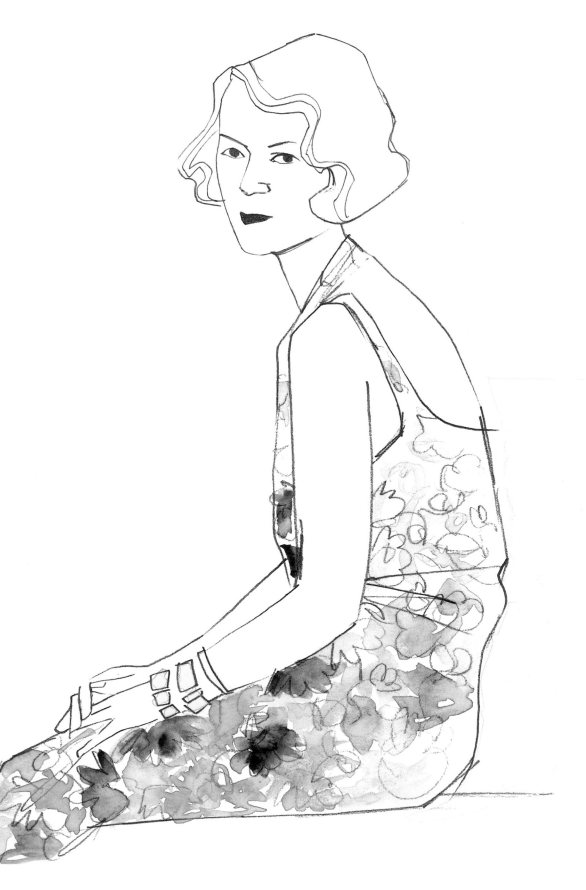

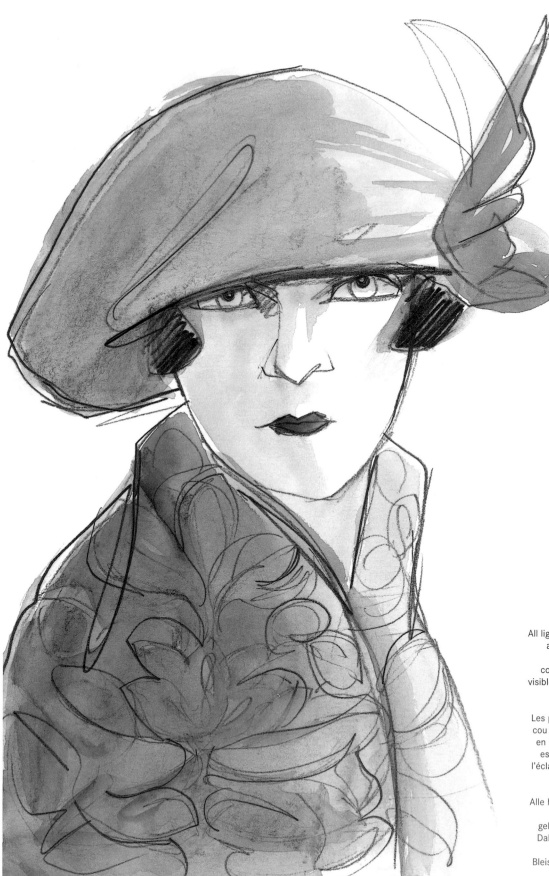

All light areas, such as the face, neck or an accessory, are left white or their colour is diluted. It is essential to consider how the light falls here. The visible pencil sketch further embellishes the illustration.

Les parties claires, comme le visage, le cou ou un accessoire, sont conservées en blanc ou atténuées. Dans ce cas, il est indispensable de tenir compte de l'éclairage. Les traits de crayon visibles embellissent l'illustration.

Alle hellen Bereiche, etwa Gesicht, Hals oder ein Accessoire, werden weiß gelassen oder farblich abgeschwächt. Dabei ist unbedingt der Lichteinfall zu berücksichtigen. Die sichtbare Bleistiftskizze schmückt die Illustration zusätzlich aus.

By graduating the colour intensity from dark to light, the direction of the light can be shown. The example shows a design by Poiret in which light and/or white areas reflect the position of the light source, found here in the top left-hand corner of the illustration.

Le dégradé dans l'intensité de la couleur, du plus foncé au plus clair, permet de représenter la lumière. Sur cette esquisse de Poiret, les zones claires ou blanches indiquent l'emplacement de la source de lumière, dans le coin supérieur gauche de l'image.

Durch die Abstufung der Farbintensität von dunkel zu hell lässt sich die Richtung des Lichteinfalls verdeutlichen. Das Beispiel zeigt einen Entwurf von Poiret, in dem helle bzw. weiße Stellen die Position der Lichtquelle reflektieren, die sich hier in der oberen linken Ecke der Illustration befindct.

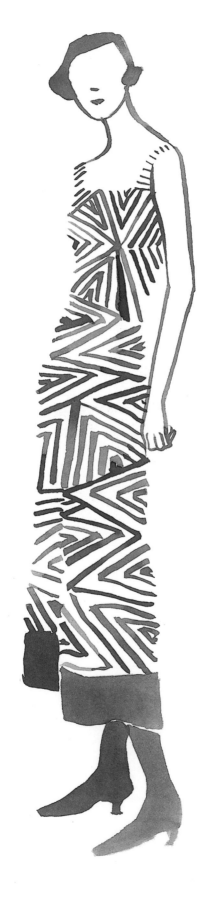

To emphasise a pattern – whether a print, embroidery or a jacquard – all pencil and/or ink contours are removed and just a single colour, not too heavily diluted, is used. This allows the pattern to be the focus of the illustration.

Pour souligner le motif d'un tissu (impression, broderie ou jacquard), effacer tous les contours réalisés au crayon ou à l'encre et se limiter à une seule couleur modérément diluée : le motif sera le cœur de l'illustration.

Zur Betonung eines Stoffmusters – sei es ein Druck, eine Stickerei oder ein Jacquard – werden alle Bleistift- bzw. Tintenkonturen entfernt, und es wird nur eine einzige, nicht zu stark verdünnte Farbe eingesetzt. Auf diese Weise steht das Muster im optischen Mittelpunkt der Illustration.

Swiftly drawn contours and copiously thinned watercolour give a dynamic appearance to an illustration. The example shows a tunic dress by Sonia Delaunay, the queen of Art Deco. The use of pure colours in her designs was influenced by Cubism and the painters Gauguin and van Gogh.

Un tracé rapide et une aquarelle très diluée donnent plus de dynamique à une image. Sur cet exemple, on voit une robe-tunique de Sonia Delaunay, la reine de l'Art déco. L'utilisation de couleurs pures dans ses esquisses montre l'influence du cubisme et des peintres Gauguin et van Gogh.

Eine flüchtige Linienführung und reichlich verdünnte Aquarellfarbe lassen eine Abbildung dynamisch erscheinen. Das Beispiel zeigt ein Tunika-Kleid von Sonia Delaunay, der Königin des Art déco. Die Verwendung reiner Farben in ihren Entwürfen wurde vom Kubismus und den Malern Gauguin und van Gogh beeinflusst.

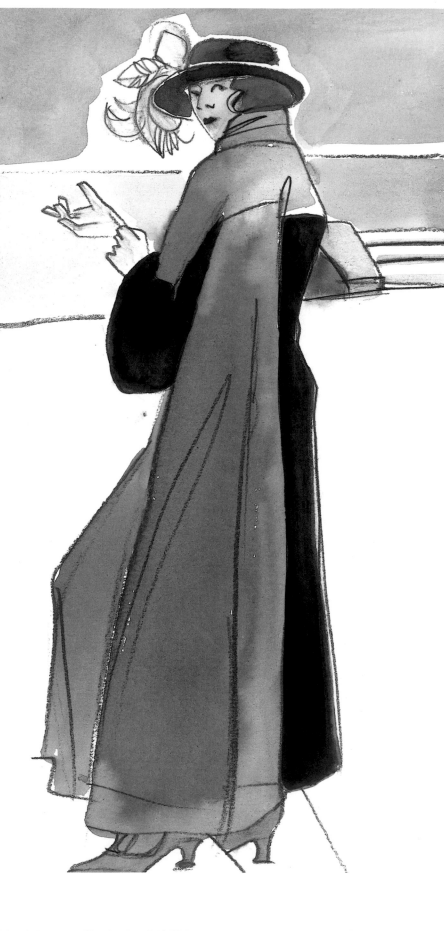

An abstract or representational background can add further information, for example the social background, to an illustration, or it can tell or indicate a story. The illustration shows a coat designed by Poiret.

Un arrière-plan abstrait ou figuratif peut apporter des informations supplémentaires, par exemple sur le contexte social, pour compléter une illustration, raconter ou évoquer une histoire. Le manteau de l'illustration a été créé par Poiret.

Ein abstrakter oder gegenständlicher Hintergrund kann eine Illustration um weitere Informationen ergänzen, beispielsweise den sozialen Kontext, oder eine Geschichte erzählen oder andeuten. Die Abbildung zeigt einen von Poiret entworfenen Mantel.

The background can be drawn in detail or schematically and only contain a few elements, so that the attention of the onlooker is not distracted from the design. This illustration depicts a coat made from heavy material with wide lapels and collar.

L'arrière-plan peut être dessiné en détail ou schématisé seulement et ne présenter que quelques éléments afin de ne pas détourner l'attention du modèle (ici un manteau à larges revers et col coupé dans un tissu lourd).

Der Hintergrund kann detailliert oder schematisch gezeichnet sein und nur wenige Elemente enthalten, sodass die Aufmerksamkeit des Betrachters nicht vom Modellentwurf abgelenkt wird. Diese Abbildung zeigt einen Mantel aus schwerem Stoff mit breitem Aufschlag und Kragen.

To draw representational backgrounds, your own photos can be used as practical models and can indirectly contribute to the creation of individual illustrations. Heavily diluted watercolours were used here; the background is suggested by single, vigorous strokes.

Pour des arrière-plans figuratifs, des photos peuvent servir de modèles et contribuer indirectement à une illustration plus personnelle. Ici, des aquarelles très diluées ont été utilisées et l'arrière-plan est simplement évoqué par quelques traits de couleurs plus vives.

Zum Zeichnen gegenständlicher Hintergründe können eigene Fotos als praktische Vorlagen dienen und indirekt zur individuellen Gestaltung der Illustrationen beitragen. Hier wurden stark verdünnte Aquarellfarben verwendet, der Hintergrund wird durch einzelne kräftige Striche angedeutet.

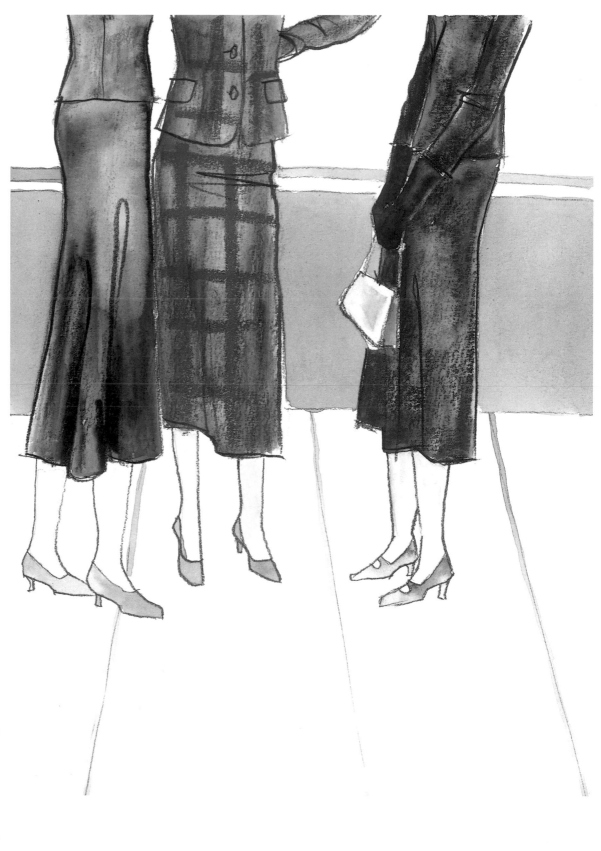

This illustration was produced in watercolour and wax colours. The latter are suitable for depicting check patterns, smooth woollen material, or wool-like textures. At the end of the Twenties, women were wearing longer skirts again, following a period – only a few years earlier – when skirts barely covered the knees.

Cette illustration a été réalisée avec des aquarelles et des peintures à la cire. On utilise la peinture à la cire pour représenter par exemple des motifs à carreaux, des tissus pure laine ou des textures laineuses. À la fin des années vingt, la mode a de nouveau rallongé les jupes alors qu'à peine quelques années plus tôt, elles couvraient tout juste le genou.

Diese Illustration wurde mit Aquarell- und Wachsfarben angefertigt. Letztere eignen sich zur Darstellung karierter Stoffmuster, glatter Wollstoffe oder wollähnlicher Texturen. Ende der 1920er Jahre trug man wieder längere Röcke, nachdem die Rockmode wenige Jahre zuvor kaum das Knie bedeckt hatte.

Watercolour technique is well suited to the portrayal of silk or silk-like fabrics, as shown in this illustration. Pastel shades make the effect even more impressive. What is particularly interesting about this illustration is that the pencil sketch shows through in some areas, but not in others.

L'aquarelle se prête très bien à la représentation de la soie ou d'étoffes soyeuses. L'effet est encore plus réussi avec des tons pastel. Cette illustration doit son intérêt particulier aux traits de crayon qui transparaissent par endroits et pas d'autres.

Die Aquarelltechnik ist gut geeignet für die Darstellung von Seide oder seidenartigen Stoffen, wie auf dieser Abbildung gezeigt. Mit Pastelltönen lässt sich eine noch eindrucksvollere Wirkung erzielen. Besonders interessant an dieser Illustration ist, dass an einigen Stellen der Bleistiftentwurf durchscheint und an anderen nicht.

The emphasis lies on the black contours of the profile, which gives the illustration greater intensity. The dark outline enables certain areas of the figure to be highlighted. The use of crayons and watercolours makes the drawing extremely vivid.

Souligner les contours noirs permet de donner plus de relief à l'image. Certaines zones entourées d'un trait sombre peuvent être particulièrement mises en valeur. L'association de crayons de couleurs et d'aquarelle rend le dessin très vivant.

Die Betonung der schwarzen Konturen verleiht der Illustration eine größere Intensität. Der dunkle Umriss ermöglicht es, bestimmte Bereiche der Figur hervorzuheben. Die Verwendung von Farbstiften und Aquarellfarben lässt die Zeichnung äußerst lebendig wirken.

In the Twenties, hats, dresses and coats emerged that were both simple and elegant, as shown in these designs by Poiret. In the first illustration, the clothes are depicted completely in watercolour. In the second one, a few areas are left white to suggest the presence of light.

Les années 20 ont vu apparaître des chapeaux, des robes et des manteaux aussi simples qu'élégants, comme sur ces dessins de Poiret. Sur le premier, le vêtement a été entièrement peint à l'aquarelle, tandis que sur le second, quelques zones blanches reflètent la lumière.

In den 1920er Jahren kamen ebenso einfache wie elegante Hüte, Kleider und Mäntel auf, wie diese Entwürfe von Poiret zeigen. Bei der ersten Illustration wurde die Kleidung vollständig mit Aquarellfarbe ausgeführt. In der zweiten Abbildung deuten einige weiße Bereiche den Lichteinfall an.

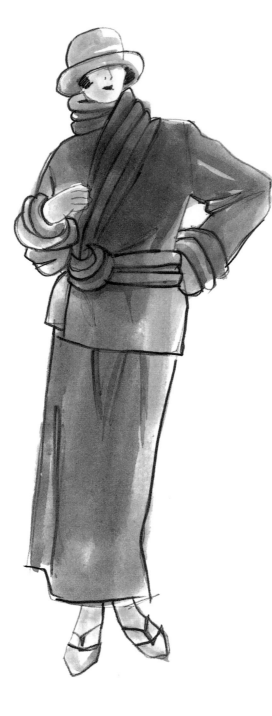

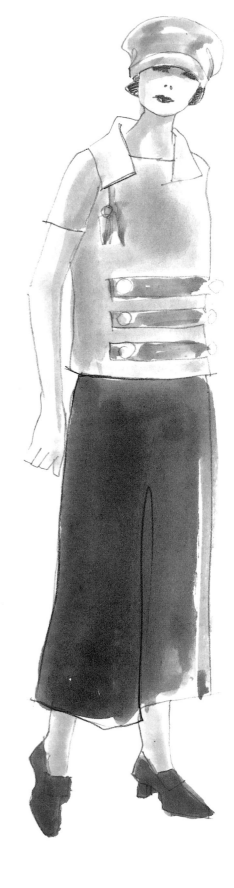

A soft black pencil and heavily diluted watercolour were used here. The areas left white reflect the light coming from the left. The soft pencil and thinly applied watercolour enable a true-to-detail and subtle rendition of the design.

Cette illustration a été réalisée avec un crayon noir à la mine tendre et de l'aquarelle très diluée. Les zones laissées en blanc reflètent la lumière qui vient de la gauche. La mine tendre et la couche fine d'aquarelle permettent un rendu des détails fidèle et nuancé.

Hier wurden ein weicher Schwarzstift und stark verdünnte Aquarellfarbe verwendet. Die weiß ausgesparten Stellen reflektieren den Lichteinfall, der hier von links kommt. Der weiche Stift und die nur dünn aufgetragene Aquarellfarbe erlauben eine detailgetreue und nuancierte Wiedergabe des Entwurfs.

In this illustration, the light on the fabric is to be emphasised, as much as the folds and the draping, to give the design character. Keeping the pencil strokes is a matter of taste, however, these do add to the impression of a detailed illustration.

Sur cette illustration, il s'agissait de souligner autant le jeu de la lumière sur l'étoffe que les fronces et les plissés, pour donner plus de caractère au modèle. Conserver ou non les traits de crayon est une question de goût mais ils renforcent l'impression de précision.

In dieser Abbildung sollte der Lichteinfall auf dem Stoff ebenso betont werden wie die Falten und der Faltenwurf, um dem Modell Charakter zu verleihen. Die Beibehaltung der Bleistiftstriche ist zwar Geschmackssache, allerdings erhöhen diese den Eindruck einer detailliert ausgeführten Illustration.

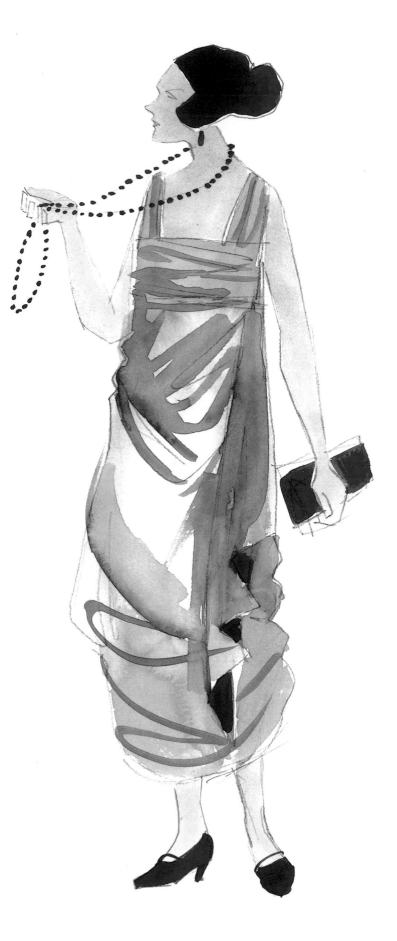

To emphasise the contours, heavy black brushstrokes are a good alternative to pencil – the figure's presence is increased in this way. Light is again suggested by unpainted areas.

Pour souligner les contours, les épais traits noirs constituent une bonne alternative au crayon et confèrent beaucoup plus de présence au personnage. La lumière est, là encore, exprimée par des zones réservées en blanc.

Zur Betonung von Konturen sind kräftige schwarze Striche eine gute Alternative zum Bleistift – die Präsenz der Figur wird so deutlich gesteigert. Der Lichteinfall wird wieder mit weiß ausgesparten Stellen angedeutet.

The picture in the foreground, executed
in heavily diluted watercolour with areas
left white to suggest the way the light
falls, depicts a very shiny dress made
from satin or viscose. The figures in the
background, painted in very fluid
watercolour which barely defines their
contours, give the drawing perspective
and vitality.

L'image du premier plan, peinte à
l'aquarelle très diluée avec des zones
blanches pour refléter la lumière,
représente une robe de satin ou de
viscose très brillante. Les personnages
de l'arrière-plan, aux contours flous et
peints à l'aquarelle très liquide, donnent
à l'ensemble plus de perspective et de
vie.

Das Bild im Vordergrund, ausgeführt mit
stark verdünnter Aquarellfarbe und
weißen Stellen, um den Einfall des Lichts
anzudeuten, zeigt ein stark glänzendes
Kleid aus Satin oder Viskose. Die
Figuren im Hintergrund, die kaum
konturiert sind und mit sehr flüssiger
Aquarellfarbe aufgetragen wurden,
geben der Zeichnung Perspektive und
Lebendigkeit.

This illustration of bags with different textures, shadows and highlights is an exercise in perspective and volume. By depicting the shine of certain materials with white speckles of light, and blending colours and omitting highlights for a matt effect, the texture of the materials is well brought out.

Cet exercice de perspective et de volume présente des sacs de différentes textures avec leurs ombres et leurs éclats. La peinture des étoffes luisantes, dont la luminosité est rehaussée par des touches de blanc, ou des tissus mats, sans brillant ni altération de la couleur, fait parfaitement ressortir la texture des différentes matières.

Diese Übung zu Perspektive und Volumen zeigt Taschen mit verschiedenen Texturen, Schatten und Glanzlichtern. Durch die Darstellung der glänzenden Stoffe mit weißen Tupfen als Glanzlichter bzw. der matten Stoffe ohne Glanzlichter und Farbverlauf wird die Materialtextur gut herausgearbeitet.

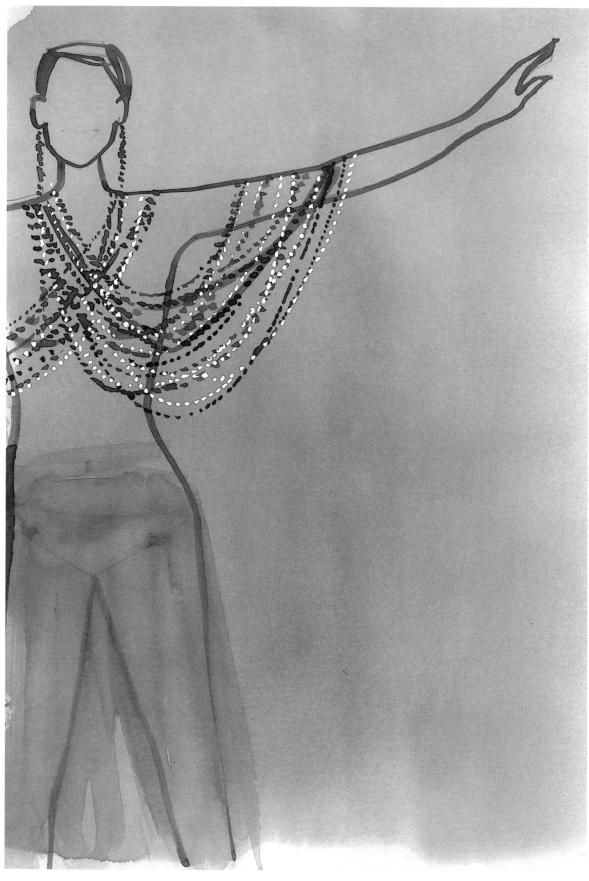

Here, the focus is entirely on the necklace. Very wet colour was first applied to the background and then, when dry, the figure was sketched in watercolour. The glittering effect is achieved with white gouache. The popularity of luxurious accessories was due not least to the success of the Ballets Russes at the end of the 1880s.

Le collier attire ici tous les regards. Le personnage a été dessiné à l'aquarelle sur un fond sec, réalisé préalablement avec une peinture très humide. L'effet scintillant est obtenu avec de la gouache blanche. Le succès des accessoires somptueux s'explique en partie par celui des Ballets russes à la fin des années 80 du XIXe siècle.

Hier liegt das Augenmerk ganz auf dem Halsschmuck. Auf den zuvor mit sehr feuchter Farbe aufgetragenen und anschließend getrockneten Hintergrund wurde mit Aquarellfarbe die Figur gezeichnet. Der Glitzereffekt wird durch die weiße Gouache erzielt. Die Beliebtheit üppiger Accessoires beruhte nicht zuletzt auf dem Erfolg der Ballets Russes am Ende der achtziger Jahre des 19. Jahrhunderts.

The different shades of brown for this little fur jacket are achieved in several steps. First of all, heavily diluted watercolour is applied. When the first application is dry, the texture of the fur is created with stronger colours. For the silky skirt with the clearly defined folds, one must ensure that the pattern adapts to the folds.

Les différentes nuances de brun de cette courte veste de fourrure ont été réalisées en plusieurs étapes : tout d'abord, une aquarelle très diluée a été appliquée et une fois sèche, la texture de la fourrure a été rendue à l'aide de couleurs plus sombres. Pour la jupe soyeuse et très froncée, il importe de veiller à adapter les motifs aux plis de l'étoffe.

Die verschiedenen Brauntöne für dieses Pelzjäckchen werden in mehreren Schritten erreicht: Zunächst wird stark verdünnte Aquarellfarbe aufgetragen. Wenn der erste Farbauftrag getrocknet ist, wird die Pelztextur mit kräftigeren Farben angelegt. Beim Rock aus seidigem Stoff mit starkem Faltenwurf ist darauf zu achten, das Muster den Falten anzupassen.

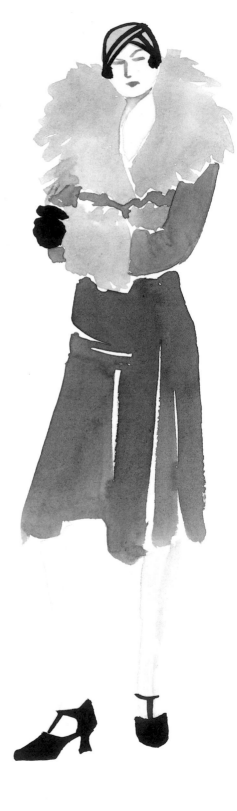

Furs can be illustrated in various ways. On the left, the fur has no shadows, but is depicted with a lot of volume. The illustration on the right, however, has considerably more detail and shows colour graduations. Both designs were painted in diluted watercolour.

La fourrure peut être reproduite de différentes manières : à gauche, elle est représentée sans ombre mais avec beaucoup de volume, tandis qu'à droite, le dessin est beaucoup plus détaillé et montre notamment les dégradés de couleur. Les deux illustrations ont été réalisées à l'aquarelle très diluée.

Pelze lassen sich unterschiedlich illustrieren. Links ist der Pelz ohne Schatten, jedoch mit viel Volumen dargestellt. Die rechte Illustration dagegen ist wesentlich detaillierter und zeigt Farbabstufungen. Beide Entwürfe wurden in stark verdünnter Aquarellfarbe ausgeführt.

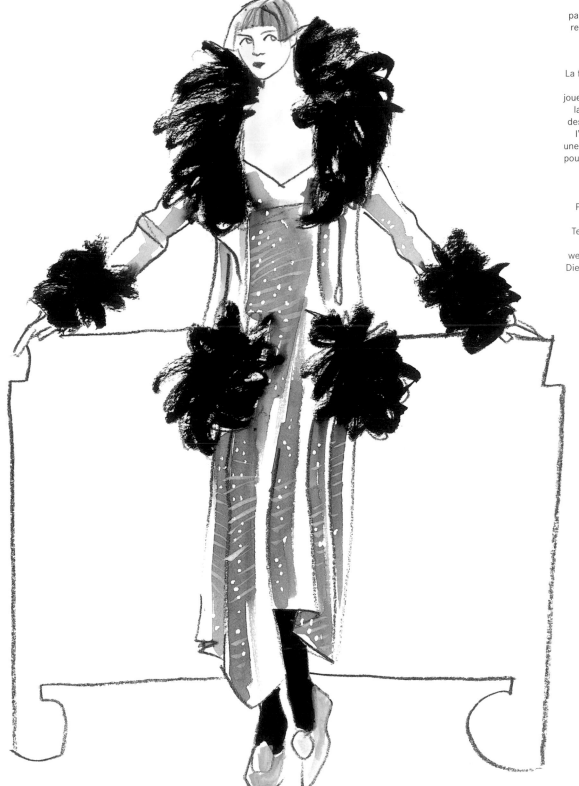

The fur for this evening dress by Patou – who, with his pleated skirts and straight-knitted jackets for the tennis player Suzanne Lenglen made a name for himself – was painted in strong, barely diluted watercolour. This technique particularly lends itself to monochrome rendering of certain pieces of clothing. The shine was achieved with white gouache.

La fourrure assortie à cette robe du soir de Patou, qui doit sa célébrité à la joueuse de tennis Suzanne Lenglen pour laquelle il a créé des jupes plissées et des gilets de laine droits, a été peinte à l'aquarelle peu diluée de couleur vive, une technique particulièrement indiquée pour les vêtements unis. L'éclat en a été rehaussé à la gouache blanche.

Der Pelz für dieses Abendkleid von Patou, der sich mit Plisseeröcken und geraden Strickjacken für die Tennisspielerin Suzanne Lenglen einen Namen machte, wurde mit kräftiger, wenig verdünnter Aquarellfarbe gemalt. Diese Technik bietet sich bei einfarbiger Gestaltung von Kleidungsstücken besonders an. Der Glanz wurde mit weißer Gouache aufgesetzt.

When presenting a transparent piece of clothing, you should begin with the body first of all. When the skin colour is dry, the dress can be painted over it in flowing colour. Then you add the pattern using barely diluted watercolour. After repeated drying, the folds are added last in a slightly darker colour than that of the clothing.

Pour représenter un vêtement transparent, commencer par dessiner le corps. Une fois que la couleur de la peau est sèche, peindre la robe par-dessus avec une peinture liquide, puis ajouter les motifs avec une aquarelle très peu diluée. Après avoir de nouveau laissé sécher, marquer les plis dans la même couleur que celle du vêtement, mais plus foncée.

Wenn ein transparentes Kleidungsstück gezeigt werden soll, beginnt man zunächst mit dem Körper. Ist die Hautfarbe trocken, wird das Kleid mit flüssiger Farbe darüber gemalt. Dann fügt man das Muster mit kaum verdünnter Aquarellfarbe hinzu. Nach abermaligem Trocknen werden schließlich die Falten in der etwas abgedunkelten Farbe des Kleides hinzugefügt.

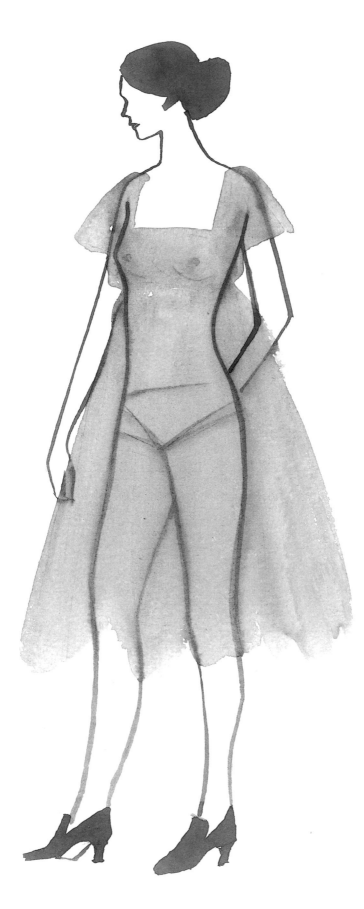

In this example too, the contours of the figure are drawn first, then the shape and volume of the dress is added using heavily diluted watercolour. Due to the schematic depiction, colour and volume form the centrepiece of the illustration.

Là aussi, on a commencé par tracer la silhouette, avant de poser la robe à l'aquarelle très diluée pour lui donner forme et volume. Le dessin très schématique reste en retrait au profit de la couleur et des volumes.

Auch bei diesem Beispiel werden zunächst die Konturen der Figur gezeichnet; dann wird das Kleid mit stark verdünnter Aquarellfarbe mit Form und Volumen aufgetragen. Durch die schematische Darstellung stehen allein Farbe und Volumen im Mittelpunkt der Abbildung.

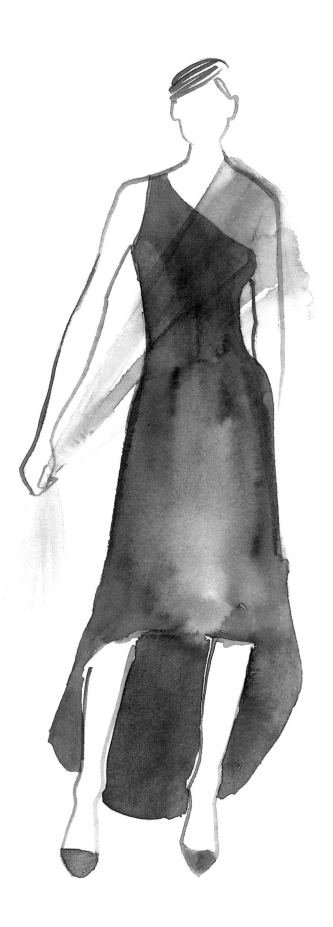

The same applies when shawls, capes, boleros or other transparent accessories need to be depicted: the first step must be to draw the outlines of the figure. The dress is then painted. Once all the colours are dry, the shawl is finally added using very fluid watercolour.

Pour les écharpes, capes, boléros ou autres accessoires transparents aussi, les silhouettes doivent être dessinées avant le vêtement. Une fois que toutes les couleurs sont parfaitement sèches, l'écharpe est ajoutée à l'aquarelle très liquide.

Auch wenn Schals, Umhänge, Boleros oder sonstige transparente Accessoires gezeigt werden sollen, müssen im ersten Schritt die Konturen der Figur gezeichnet werden. Dann wird das Kleid aufgetragen. Sind alle Farben gut getrocknet, wird zuletzt der Schal mit sehr flüssiger Aquarellfarbe hinzugefügt.

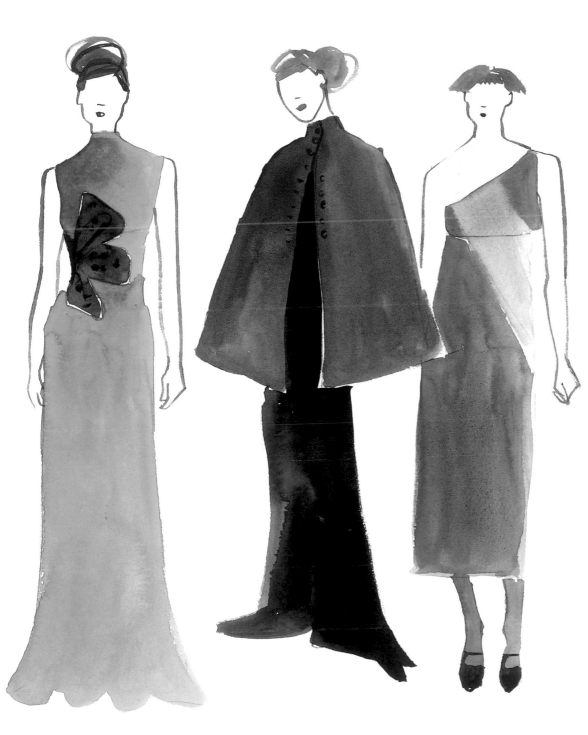

If one works schematically with swift strokes and luminous, free-flowing watercolour, the result is a simple but very expressive picture. As the pencil sketch was dispensed with here, the pattern and volume are emphasised in these dresses by the artist Schiaparelli, who introduced Surrealism to haute couture.

Le dessin schématique, à traits rapides et aquarelles lumineuses appliquées très liquides, donne un résultat simple mais très expressif. On a ici renoncé à toute esquisse au crayon afin de souligner les motifs et les volumes de ces robes créées par l'artiste Schiaparelli, qui a introduit le surréalisme dans la haute couture.

Wenn man schematisch mit flüchtigen Strichen und leuchtenden, stark flüssig aufgetragenen Aquarellfarben arbeitet, ist das Ergebnis eine schlichte, aber ausdrucksstarke Zeichnung. Da hier auf einen Bleistiftentwurf verzichtet wurde, werden Muster und Volumen bei diesen Kleidern der Künstlerin Schiaparelli betont, die den Surrealismus in die Haute Couture brachte.

This double-page spread shows two versions of the same design, a transparent dress embroidered in a single colour by Madeleine Vionnet, who many believe to be the best fashion designer ever – even above Coco Chanel. In the first picture, the embroidery is emphasised, whilst in the second it is toned-down.

Deux versions du même modèle, une robe transparente aux broderies unies de Madeleine Vionnet, considérée par beaucoup comme la meilleure créatrice de mode de tous les temps, avant Coco Chanel. La première image souligne la broderie, mise très en retrait sur la deuxième.

Diese Doppelseite zeigt zwei Ausführungen desselben Entwurfs, eines transparenten, einfarbig bestickten Kleides von Madeleine Vionnet, die viele für die beste Modedesignern überhaupt halten – noch vor Coco Chanel. Im ersten Bild wird die Stickerei betont, im zweiten ist sie stark zurückgenommen.

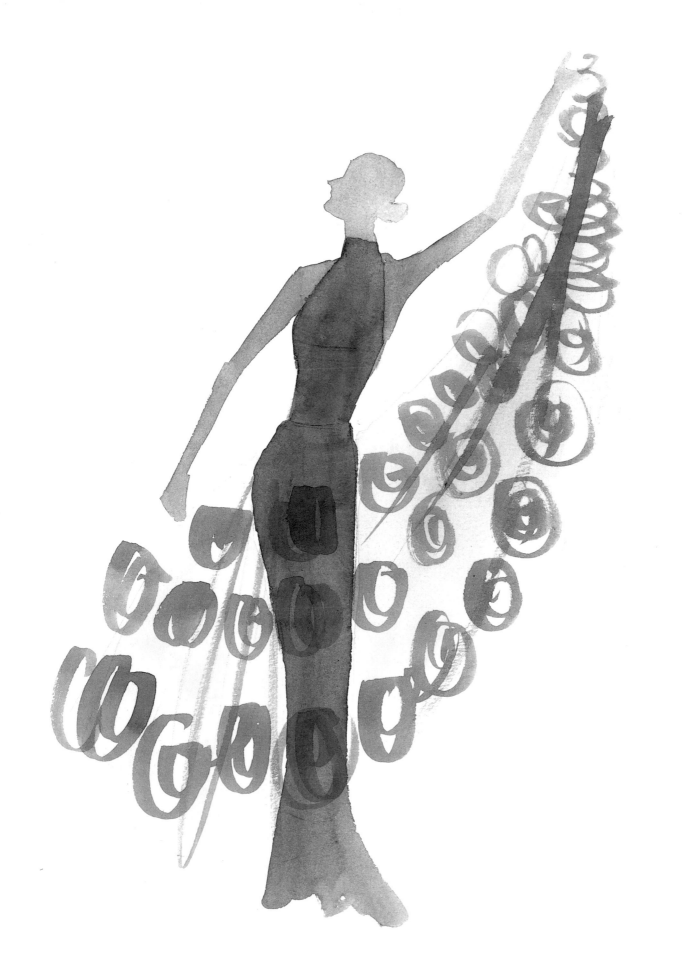

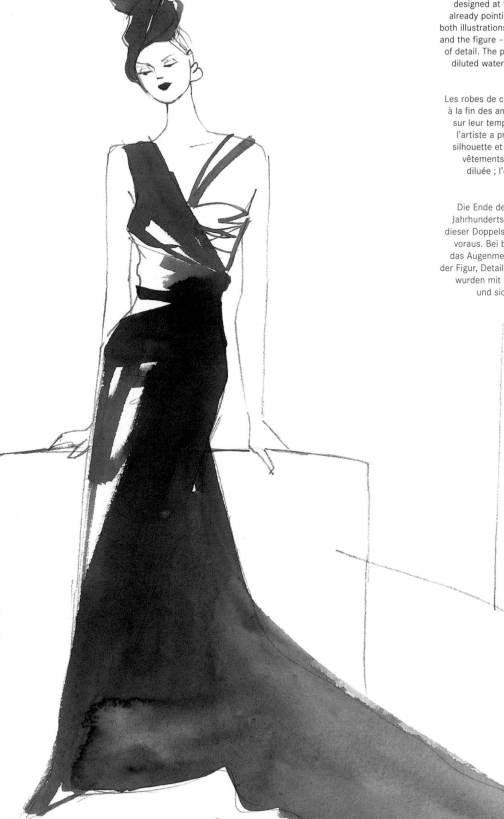

The dresses on this double-page spread designed at the end of the 1930s are already pointing towards the future. In both illustrations, the focus is on volume and the figure – there is a complete lack of detail. The pictures were executed in diluted watercolour with visible pencil sketching.

Les robes de cette double-page, créées à la fin des années 30, sont en avance sur leur temps. Pour ces illustrations, l'artiste a privilégié les volumes et la silhouette et renoncé aux détails. Les vêtements sont peints à l'aquarelle diluée ; l'esquisse au crayon reste visible.

Die Ende der dreißiger Jahre des 20. Jahrhunderts entworfenen Kleider auf dieser Doppelseite greifen schon etwas voraus. Bei beiden Illustrationen liegt das Augenmerk auf dem Volumen und der Figur, Details fehlen völlig. Die Bilder wurden mit verdünnter Aquarellfarbe und sichtbarem Bleistiftentwurf ausgeführt.

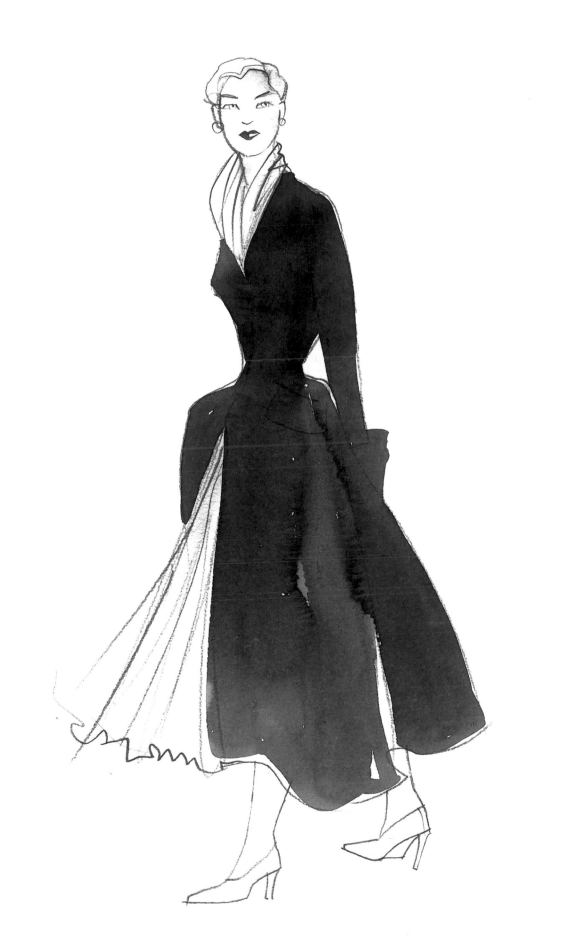

PASTELS

LES PASTELS SECS / PASTELLKREIDE

The term "pastel" is derived from the Italian pasta, or dough. Pastels consist of powder pigments and a binder, such as gum or gypsum. Pastel colours are luminous, intense and saturated. They are directly applied to high-grammage paper and can easily be touched up. So they are often used for illustrations that might need adjustments.

Le terme pastel est dérivé de l'italien pasta, pâte. Les pastels secs sont composés de pigments en poudre et de liants tels que la gomme ou la poudre de craie. Leurs couleurs sont très vives, intenses et soutenues. Ils sont appliqués directement sur un papier à grammage élevé et peuvent facilement être retouchés, c'est pourquoi les pastels secs sont souvent utilisés pour des illustrations qui nécessiteront éventuellement une correction.

Der Begriff Pastell leitet sich vom italienischen pasta, also Teig, ab. Pastellkreiden bestehen aus Pulverpigmenten und Bindemitteln, wie Gummi oder Gips. Die Farben der Pastellkreiden sind leuchtend, intensiv und satt. Sie werden direkt auf Papier mit hoher Grammatur aufgetragen und lassen sich leicht ausbessern. Daher werden sie häufig für Illustrationen verwendet, die möglicherweise Korrekturen erfordern.

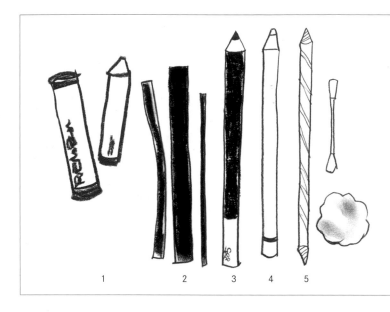

1. Pastel sticks or crayons; available in countless shades
2. Charcoal pencils in various shades; they are principally used for drafts or sketches, as they can easily be erased
3. Graphite pencil
4. White pencils, for gloss and highlights
5. Blending sticks and cotton wool buds

1. Pastels secs ; on les trouve en d'innombrables nuances dans le commerce
2. Fusain ; il en existe de différentes épaisseurs, il est surtout utilisé pour les esquisses ou les brouillons car il est facile à gommer
3. Crayon graphite
4. Crayon blanc ; pour le brillant et les jeux de lumière
5. Crayon estompeur et bâtonnets ouatés

1. Pastellkreide; ist in unzähligen Schattierungen im Handel erhältlich
2. Kohlestift; gibt es in unterschiedlichen Stärken und wird vor allem für Entwürfe oder Skizzen benutzt, da er sich leicht ausradieren lässt
3. Graphitstift
4. Weißstift; für Glanz- und Lichteffekte
5. Wischstift und Wattestäbchen

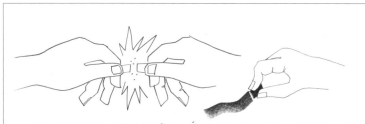

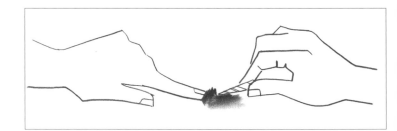

1. Pastels are broken before use as large areas can be worked on better with short, thick sticks.
1. Les pastels secs sont brisés avant leur utilisation car il est plus facile de travailler les grandes surfaces avec des morceaux courts et larges.
1. Pastellkreide wird vor der Benutzung gebrochen, weil sich große Flächen besser mit breiten, kurzen Stücken bearbeiten lassen.

2. Several techniques are used to smudge the colour, including a blending stick, the finger or a cotton wool bud.
2. Il existe plusieurs méthodes pour étaler les couleurs : avec un crayon estompeur, avec les doigts ou avec un bâtonnet ouaté.
2. Es gibt mehrere Techniken, um die Farben zu verwischen, etwa den Wischstift, die Finger oder ein Wattestäbchen.

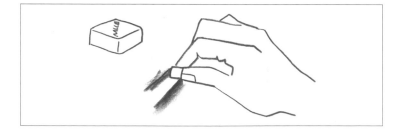

3. To obtain highlight and shadow effects, one can use a normal or kneadable India rubber or white pencils.
3. Pour le brillant et les ombres, on peut utiliser une gomme normale ou une gomme malléable (« mie de pain »), ou encore des crayons blancs.
3. Um Glanz- und Schatteneffekte zu erzielen, kann man einen normalen oder knetbaren Radiergummi oder Weißstifte verwenden.

4. Since pastel crayons, drawing charcoal and graphite pencils do not adhere well to paper, the drawing should be sprayed with a fixative as soon as it is finished.
4. Comme les pastels secs, le fusain et le graphite adhèrent mal au papier, il faut fixer le dessin dès qu'il est achevé avec un fixatif en bombe aérosol.
4. Da Pastellkreide, Zeichenkohle und Graphit nur schlecht auf Papier haften, sollte die fertige Zeichnung möglichst sofort mit einem Spray fixiert werden.

Pastel crayons yield similar results to wax crayons, but you must be careful not to smudge the drawing in the end so as to preserve the structure. The two illustrations below show smudged (1) and unsmudged (2) pastel crayon.

Les pastels secs donnent des résultats semblables à ceux des pastels à l'huile, mais il est inutile d'estomper les couleurs pour conserver la structure du dessin. Les deux illustrations qui suivent sont réalisées l'une avec un pastel estompé (1), l'autre avec un pastel non estompé (2).

Mit Pastellkreide lassen sich ähnliche Resultate wie mit Wachskreide erzielen, allerdings darf man die Zeichnung abschließend nicht verwischen, um so ihre Struktur zu bewahren. Die beiden folgenden Illustrationen zeigen verwischte (1) und nicht verwischte (2) Pastellkreide.

1

2

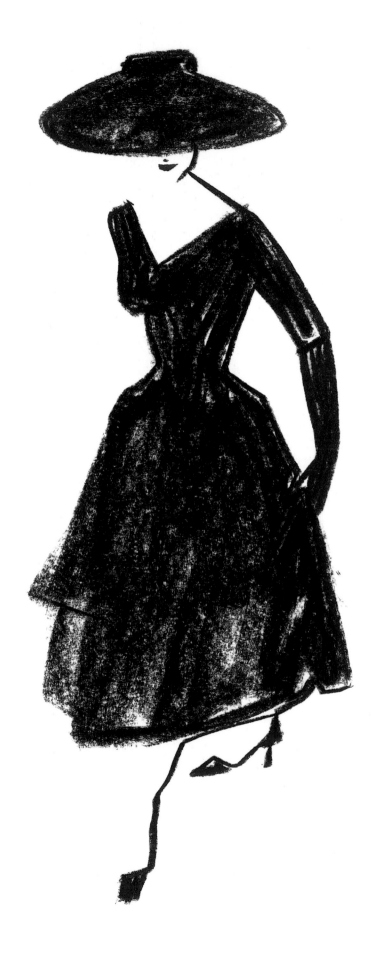

Pastel crayons are applied exactly like wax crayons, but they smudge far more easily. In this example, the extremely dense black areas were achieved with the tip of the pastel crayon.

Les pastels secs sont utilisés de la même manière que ceux à l'huile mais s'estompent beaucoup plus facilement. Sur cet exemple, la surface noire très compacte a été obtenue avec la pointe de la craie.

Pastellkreide wird genau wie Wachskreide aufgetragen, verwischt jedoch wesentlich leichter. Bei diesem Beispiel wurde die sehr kompakte schwarze Fläche mit der Spitze der Pastellkreide erzielt.

The strong red streak accentuates the contours of the model's back and, like a shadow, it lifts the drawing from the background to produce a three-dimensional effect. This prevents the appearance of a figure hovering above an empty background.

La ligne rouge épaisse souligne le contour du dos et détache le dessin de l'arrière-plan comme une ombre, de manière à créer une impression en trois dimensions. On peut ainsi éviter les personnages « flottants » en l'absence de fond.

Der kräftige rote Streifen betont die Rückenkontur des Models und hebt die Zeichnung vom Hintergrund ab, sodass ein dreidimensionaler Eindruck entsteht. Auf diese Weise wird ein „Schweben" der Figur vor fehlendem Hintergrund vermieden.

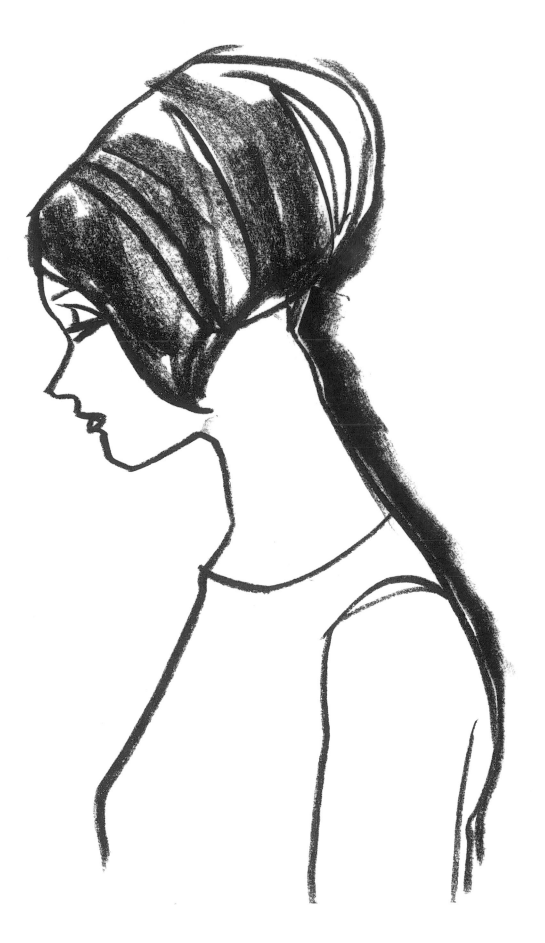

Using the broad side of the crayon, textures like embossed and cloqué fabric can be depicted realistically on coarse-grained paper. The colour powder for the delicate background was applied with cotton wool.

Le côté large de la craie permet de représenter avec réalisme sur du papier à grain épais des structures telles que les matières gaufrées ou les tissus cloqués. La couleur délicate et fondue de l'arrière-plan a été appliquée avec du coton.

Mit der breiten Kreideseite lassen sich auf grobkörnigem Papier realistische Strukturen darstellen, zum Beispiel Prägemuster und Cloqué-Gewebe. Das Farbpulver für den zarten Hintergrund wurde mit Watte aufgetragen.

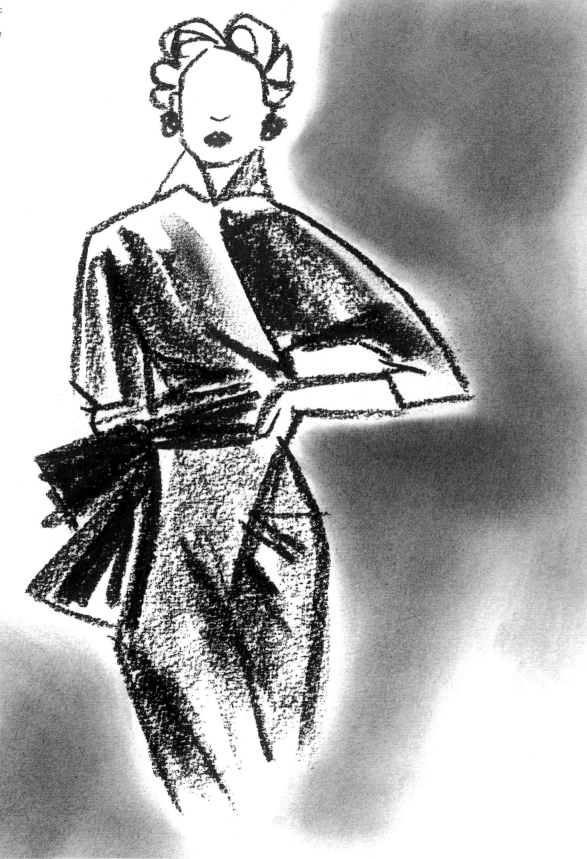

Simple, no-nonsense articles of clothing were drawn with the tip of the pastel crayon just as they would be with a pencil. The illustration looks fresher and more spontaneous when the pattern slightly overlaps the outlines of the figure, as it does here.

Les vêtements simples et droits sont dessinés avec la pointe de la craie comme avec un crayon à papier. L'illustration prend un caractère plus spontané et frais lorsque, comme ici, le motif dépasse légèrement les contours de la silhouette.

Geradlinige, schlichte Kleidungsstücke werden mit der Spitze der Pastellkreide wie mit einem Bleistift gezeichnet. Die Illustration wirkt spontaner und frischer, wenn das Muster wie hier etwas über die Konturen der Figur hinausgeht.

Masking fluid or a stencil defines the desired shape. Finally, the background colour is applied with cotton wool and smudged, producing simple, striking drawings.

La forme voulue est laissée en blanc à l'aide de liquide à masquer ou d'un pochoir. La couleur du fond est ensuite appliquée avec du coton et estompée. Une technique qui permet d'obtenir des illustrations aussi simples qu'accrocheuses.

Mit Maskierflüssigkeit oder einer Schablone spart man die gewünschte Form aus. Anschließend wird die Farbe für den Hintergrund mit Watte aufgetragen und verwischt. So entstehen ebenso schlichte wie eindrucksvolle Zeichnungen.

Due to their composition and the ability to blend colour tones, pastels are suitable for depicting make-up and cosmetics. The larger the chosen paper format for an illustration, the easier it is to work on it, and mistakes that often appear when drawing in small formats will be avoided.

En raison de leur structure et de la possibilité de mélanger plusieurs tons, les pastels secs conviennent bien aux illustrations de maquillages et cosmétiques. Choisir un format de papier le plus grand possible pour faciliter le travail et éviter des erreurs, fréquentes sur les illustrations de petit format.

Aufgrund ihrer Struktur und der Möglichkeit, Farbtöne zu mischen, eignen sich Pastellkreiden gut für die Darstellung von Make-up und Kosmetika. Je größer das gewählte Papierformat für eine Illustration ist, desto einfacher lässt sich arbeiten, und es werden Fehler vermieden, die oft bei kleinformatigen Abbildungen auftreten.

A variety of textures can be represented
with pastel crayons, such as the napped
wool in this sketch. The figure is pre-
drawn in pencil or fibre pen; then the
colour is applied with the tip of the
pastel crayon and not smudged.

Les pastels secs permettent de
reproduire différentes textures, comme
la rude étoffe de laine grattée de cette
ébauche. Commencer par dessiner la
silhouette au crayon à papier ou au
crayon-feutre avant d'appliquer la
couleur avec la pointe de la craie, sans
estomper.

Mit Pastellkreide lassen sich
verschiedene Texturen darstellen, etwa
der geraute Wollstoff dieses Entwurfs.
Die Figur wird zunächst mit Blei- oder
Faserstift vorgezeichnet, dann wird die
Farbe mit der Spitze der Pastellkreide
aufgetragen und nicht verwischt.

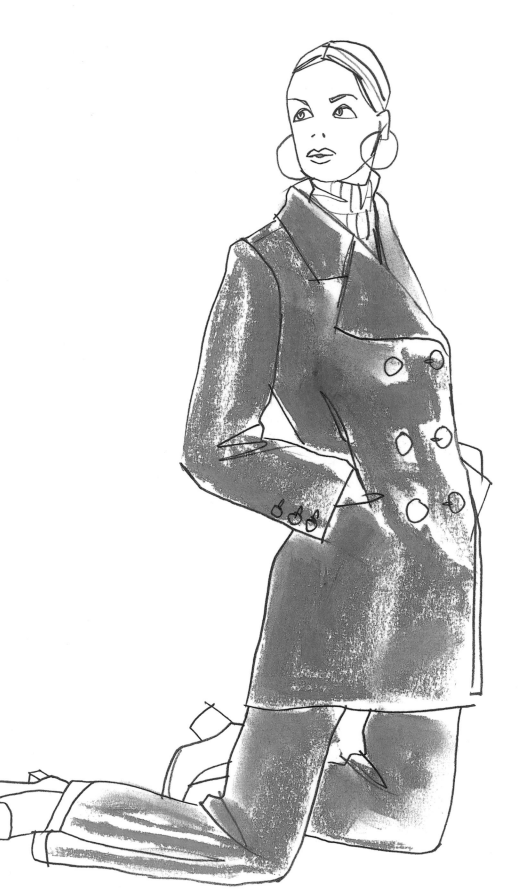

Knitwear or fluffy, voluminous fabrics such as this mohair pullover can best be illustrated using pastel crayons. Here the colour was slightly smudged with the fingers to emphasise the delicate texture of the fabric.

Les articles tricotés ou les matières moelleuses et volumineuses, comme ce pull-over en mohair, sont également bien rendus aux pastels secs. La couleur a été ici légèrement estompée avec les doigts pour mettre en évidence la nature délicate de la matière.

Auch Strickwaren oder flauschige, voluminöse Gewebe, wie dieser Mohairpullover, lassen sich gut mit Pastellkreide illustrieren. Hier wurde die aufgetragene Farbe leicht mit den Fingern verwischt, um die zarte Stoffbeschaffenheit zu verdeutlichen.

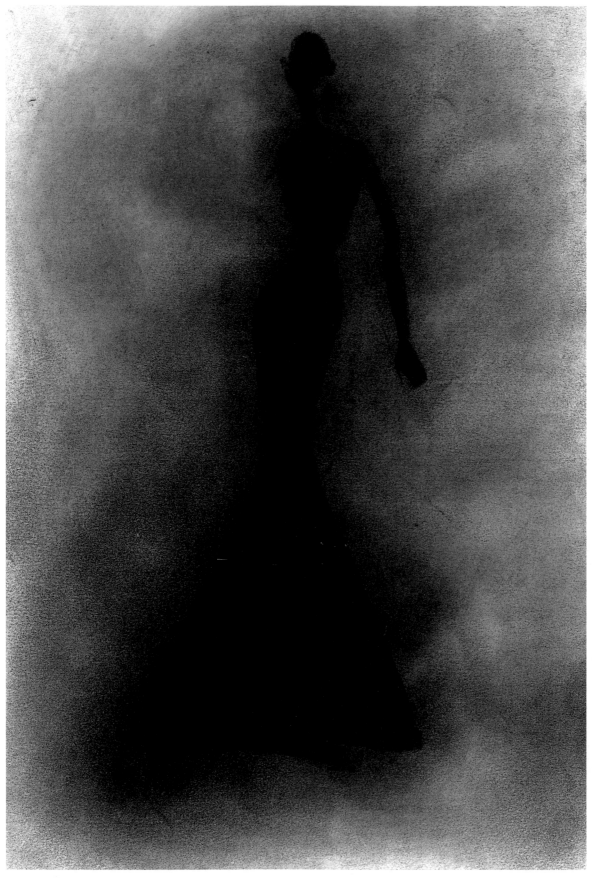

Pastel crayons can also be applied just with cotton wool to capture scant details of the design but plenty of its volume. One example is this model by Arnold Scaasi (b. 1931), a New York couturier who made a name for himself with creations for personalities like Barbara Bush and Barbra Streisand.

On peut aussi bien appliquer les pastels secs avec du coton. Si presque aucun détail du vêtement ne ressort, son volume est en revanche particulièrement mis en valeur. C'est le cas de ce modèle d'Arnold Scaasi (né en 1931), grand couturier new-yorkais connu pour ses créations pour des célébrités, comme Barbara Bush ou Barbra Streisand.

Pastellkreide lässt sich auch wunderbar nur mit Watte auftragen. Es kommen dabei zwar kaum Details des Entwurfs zum Ausdruck, dafür aber sein Volumen. Ein Beispiel ist dieses Modell von Arnold Scaasi (geboren 1931), einem New Yorker Couturier, der sich mit Kreationen für Persönlichkeiten wie Barbara Bush oder Barbra Streisand einen Namen machte.

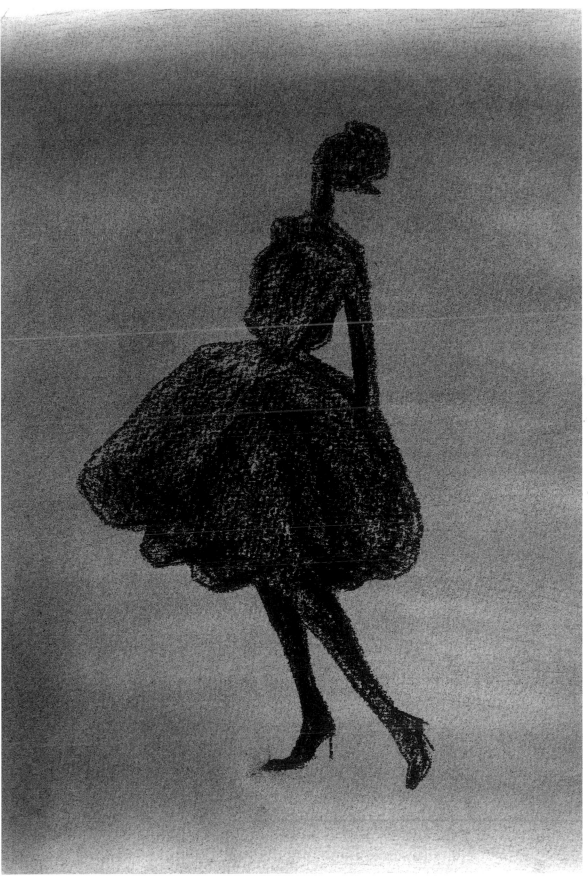

In this illustration, the background was smudged with cotton wool and the fingertips. The silhouette was drawn with the tip of the pastel crayon and left unsmudged to "lift" it from the background.

Sur cette illustration, le fond a été étalé et estompé avec du coton et avec les doigts. La silhouette dessinée avec la pointe de la craie n'a pas été estompée afin qu'elle se détache mieux de l'arrière-plan.

Bei dieser Illustration wurde der Hintergrund mit Watte und den Fingern verwischt. Die Silhouette wurde mit der Spitze der Pastellkreide aufgetragen und nicht verwischt, um sie vom Hintergrund abzuheben.

WAX CRAYONS

LES PASTELS À L'HUILE / WACHSKREIDE

Wax crayons are best suited for
depicting complex textures such as
snakeskin, fur or transparent fabrics.
After finishing an illustration, the wax
colours are then smudged, usually with
the finger. Wax crayons are also used
when realistic drawings are to be added
to photographs.

Les pastels à l'huile sont parfaits pour
représenter des textures complexes
telles que peaux de serpent, fourrures
ou étoffes transparentes. Une fois
l'illustration terminée, les couleurs sont
estompées, le plus souvent avec les
doigts. On utilise également les pastels à
l'huile pour dessiner des images
réalistes à partir de photographies.

Wachskreide eignet sich am besten zur
Darstellung komplexer Texturen wie
Schlangenhaut, Pelze oder transparente
Stoffe. Nach Fertigstellung einer
Illustration werden die Wachsfarben
meist mit den Fingern verwischt.
Wachskreide wird auch verwendet, wenn
auf der Grundlage von Fotografien
realistische Zeichnungen angefertigt
werden sollen.

1. First, a padded work surface must be created, for example by placing several layers of newspaper under the paper. This is important because it is difficult to smudge or distribute the colour evenly over the paper when it is placed on a hard surface.
1. Assouplir au préalable la surface de travail en plaçant par exemple une ou plusieurs couches de papier-journal sous la feuille de dessin. En effet, la couleur s'estompe mal sur une surface dure et il est difficile de l'étaler sur le papier.
1. Zunächst muss für eine weiche Arbeitsfläche gesorgt werden, indem man beispielsweise eine oder mehrere Lagen Zeitungspapier unter das Zeichenblatt legt. Auf harten Arbeitsflächen lässt sich die Farbe nämlich schlecht verwischen bzw. auf dem Papier verteilen.

2. Before beginning to draw, choose the desired colour and break the crayon.
2. Avant de commencer à dessiner, choisir un pastel de la couleur désirée et le briser.
2. Bevor mit der Zeichnung begonnen wird, wird eine Wachskreide in der gewünschten Farbe gewählt und zerbrochen.

3. The larger surfaces are drawn with repeated short strokes using a broader, smaller piece. In this way, the colour is applied more evenly than it would be with a long single stroke.
3. Couvrir les grandes surfaces en traçant plusieurs traits courts avec un petit morceau large : la couleur paraît ainsi appliquée plus régulièrement qu'avec un seul long trait.
3. Mit einem breiten, kleinen Bruchstück werden dann die großen Flächen mit mehreren kurzen Strichen ausgeführt. Der Farbauftrag wirkt dadurch gleichmäßiger als mit einem einzigen langen Strich.

4. Sharper crayon pieces are best used for more precise contours and to fill in smaller surfaces.
4. Les fragments de pastel pointus sont utilisés pour les contours plus précis et pour couvrir de petites surfaces.
4. Spitze Wachsstücke werden für feinere Konturen und zum Ausfüllen kleiner Flächen verwendet.

5. Only after the drawing is finished should the colours be smudged with the finger. Smudging the colours creates a hard wax film, which for the most part cannot be altered.
5. Attendre que le dessin soit entièrement terminé pour étaler les couleurs avec les doigts. L'opération crée un film de cire solide et très stable.
5. Erst wenn die Zeichnung vollkommen fertig gestellt ist, werden die Farben mit den Fingern verstrichen. Das Verwischen der Farben lässt einen festen, kaum veränderlichen Wachsfilm entstehen.

6. Small pieces of crayon left on the paper are best removed using a knife or razor blade.
6. Pour ôter les restes de gras sur le papier, le plus simple est d'utiliser un couteau ou une lame de rasoir.
6. Wachsreste auf dem Papier lassen sich am einfachsten mit einem Messer oder einer Rasierklinge entfernen.

1. To retouch a photograph, photocopy it onto uncoated, coarse paper, but never onto glossy, smooth paper.
The paper should be as large as possible (at least DIN A3 – 297 x 420 mm) since enough space is needed to apply the fatty wax crayon. The photocopy should also be as bright as possible.
The original photograph should always be kept nearby, since the photocopy will slowly be covered by the crayon colour.

1. Après avoir choisi une photographie, la photocopier sur du papier non couché légèrement rugueux, en aucun cas sur du papier couché brillant.
Prendre une très grande feuille (format A3, 297 x 420 mm, ou plus) car on a besoin de place suffisante pour pouvoir bien appliquer le pastel à l'huile. La photocopie doit être la plus claire possible.
Toujours garder la photo originale sous la main car la photocopie est peu à peu recouverte par la couleur.

1. Wenn man eine Fotografie ausgewählt hat, wird sie auf ungestrichenes, raues Papier fotokopiert, niemals auf glänzendes, gestrichenes.
Das Blatt sollte möglichst groß sein (mindestens DIN A3, 297 x 420 mm), da man ausreichend Platz braucht, um die fetthaltige Wachskreide gut auftragen zu können. Die Fotokopie sollte so hell wie möglich sein.
Das Originalfoto sollte man stets zur Hand haben, da die Fotokopie nach und nach vom Farbauftrag verdeckt wird.

2. First, the darker spaces on the original photograph should be coloured in using black or brown. If the illustration is intended to be realistic, no new outlines should be added, as the goal is just to fill in the image.

2. Commencer par les zones sombres en noir ou marron, d'après la photographie originale. Pour une illustration réaliste, ne pas tracer de nouveaux contours mais se contenter de remplir ceux du modèle.

2. Zunächst gestaltet man die dunklen Stellen entsprechend der Originalfotografie mit schwarzer oder brauner Farbe. Soll die Illustration realistisch sein, dürfen keine neuen Konturen angelegt werden, die der Vorlage werden nur ausgefüllt.

3. White helps to blend the colours, and it can also serve to correct any errors, much like a rubber eraser. The entire picture must be covered with crayon so that none of the original picture can be seen.

3. Le blanc permet de fondre et de mélanger les couleurs ou de corriger des erreurs, comme avec une gomme. La feuille doit être entièrement coloriée afin que la photocopie ne transparaisse à aucun endroit.

3. Weiße Farbe sorgt für das Verschmelzen der Farben; außerdem lassen sich damit wie mit einem Radiergummi Fehler korrigieren. Das gesamte Bild muss mit Wachskreide bedeckt werden, damit die Vorlage nirgendwo durchscheint.

4. As soon as the entire background has been covered with crayon, the colours are smudged with the finger. This creates a blurry structure and covers the last pixels of the photograph.

4. Dès que le fond est entièrement recouvert de pastel, estomper et étaler la couleur avec les doigts pour avoir une composition floue qui couvre les derniers pixels de la photo.

4. Sobald der gesamte Untergrund mit Wachskreide übermalt ist, wird die Farbe mit den Fingern verstrichen; es entsteht eine unscharfe Struktur, und auch die letzten Fotopixel werden so abgedeckt.

The dress on this page, designed by Cristóbal Balenciaga (1895–1972), was drawn using two different methods. The first version was created using the broad side of the crayon and then smudged. The monochrome drawing attracts the viewer's eye to the volume and silhouette of the dress.

La robe de cette page, une esquisse de Cristóbal Balenciaga (1895-1972), a été représentée de deux manières différentes. La première version a été dessinée avec le côté large du pastel à l'huile, puis estompée. L'absence d'autres couleurs attire l'attention sur le volume et la silhouette de la robe.

Das Kleid auf dieser Seite, ein Entwurf von Cristóbal Balenciaga (1895-1972), wurde auf zwei verschiedene Arten ausgeführt. Die erste Version wurde mit der breiten Seite des Wachsstiftes gezeichnet und anschließend verwischt. Die einfarbige Gestaltung lenkt den Blick des Betrachters auf das Volumen und die Silhouette des Kleides.

In this version, the folds are emphasised using the edge of the crayon. In this way the manner in which the dress falls around the waist is accentuated, the volume less so.

Sur cette seconde version de la même robe, les plis ont été fortement soulignés avec la pointe du pastel à l'huile, ce qui met en valeur le drapé au niveau de la taille, au détriment du volume, quelque peu négligé.

In dieser Version des Kleides wurden die Falten mit der Spitze der Wachskreide stark hervorgehoben; dadurch wird der Faltenwurf im Taillenbereich betont, das Volumen aber etwas vernachlässigt.

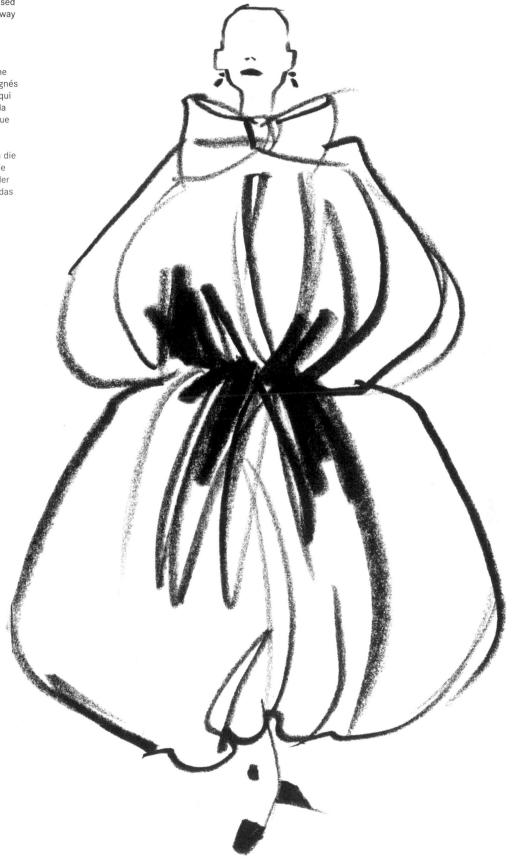

Balenciaga was one of the few dressmakers who drew his own collections and could also sew the prototypes. An example of his style – and that of the 1940s in general – is this coat, which nicely brings out the contours of the figure.

Balenciaga était l'un des rares grands couturiers capables de dessiner lui-même ses collections et de coudre ses modèles. Ce manteau est très représentatif de son style (et de celui des années 1940) qui souligne la forme de la silhouette.

Balenciaga war einer der wenigen Couturiers, die sowohl ihre Kollektionen selbst zeichnen, als auch die Modelle selbst nähen konnten. Ein Beispiel für seinen Stil – und den der vierziger Jahre des 20. Jahrhunderts – ist dieser Mantel, der die Konturen der Figur zur Geltung bringt.

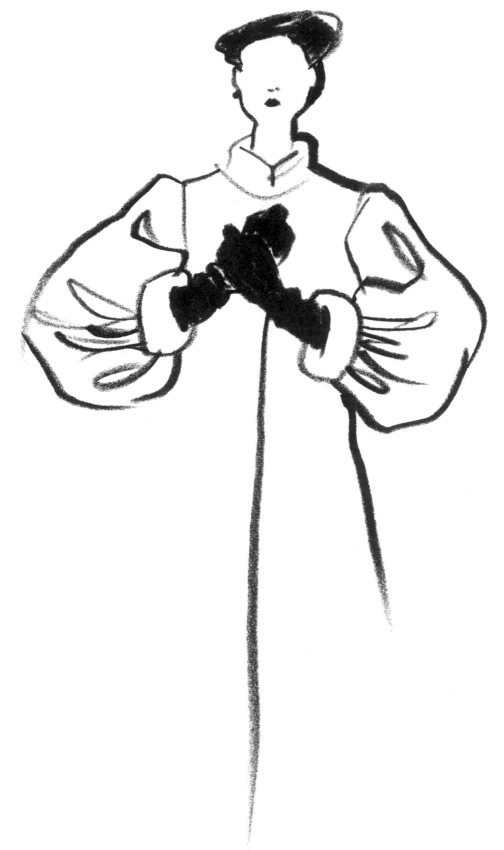

Crayon illustration can be a very expressive method of creating vivid images without great detail. To depict this pink bow, first the outlines were drawn with the edge of the crayon and then the surfaces were filled in with the broad side.

La technique aux pastels à l'huile permet de réaliser des dessins très expressifs, peu détaillés mais qui se détachent du reste. Pour cette ceinture à nœud rose, on a commencé par tracer les contours avec la pointe du pastel, avant de colorier les surfaces avec le côté large.

Wachsmalerei ist eine ausdrucksstarke Technik für Zeichnungen ohne detaillierte Ausführung, aber mit intensiver Ausstrahlung. Bei dieser rosafarbenen Schleife wurden zunächst die Konturen mit der Spitze des Wachsstiftes angelegt und anschließend die Flächen mit der breiten Kreideseite ausgefüllt.

The loose yet highly expressive lines of this illustration emphasise the main features of the designs. The primary points and angles created by the crayon lend the drawing more depth, while the red background accentuates the contours.

Le tracé léger, mais très expressif, de cette illustration souligne uniquement les éléments principaux de l'esquisse. Les différents départs de traits et angles donnent plus de profondeur au dessin, tandis que le fond rouge fait ressortir plus nettement les contours.

Die lockere, aber ausdrucksstarke Linienführung dieser Illustration betont nur die Hauptelemente des Entwurfs. Die verschiedenen Ansatzpunkte und -winkel der Wachskreide verleihen der Zeichnung mehr Tiefe. Der rote Hintergrund lässt die Konturen stärker hervortreten.

This 1940s satin dress knotted in front was drawn in the style of the time, with crayon highlights. The areas of the dress left white are intended to show the light source.

Cette robe de satin des années 1940, fermée sur le devant par des nœuds, a été réalisée dans le style de l'époque. Son éclat est rendu par le pastel à l'huile. Les petites surfaces laissées en blanc indiquent l'éclairage.

Dieses vorn mit Knoten geschlossene Satinkleid aus den vierziger Jahren des 20. Jahrhunderts wurde im Stil der damaligen Zeit mit Glanzlichtern in Wachskreide ausgeführt. Die kleinen, weiß gelassenen Stellen deuten den Lichteinfall an.

The combination of crayon and white areas in this illustration creates extremely interesting, complex volumes. The evenly drawn outlines – here with more black, there with less – serve to accentuate and lend the illustration great expressiveness. There is a marked difference between the foreground and the background.

L'association de pastels à l'huile et de surfaces blanches crée des volumes en couches multiples très intéressants. Les contours noirs, plus ou moins réguliers et uniformes, accentuent l'ensemble et confèrent plus d'expressivité au dessin. Le premier plan et l'arrière-plan sont clairement différenciés.

Die Kombination aus Wachskreide und weißen Flächen schafft höchst interessante und vielschichtige Volumen. Die schwarzen, mal mehr, mal weniger gleichmäßig gestalteten Konturen setzen Akzente und verleihen der Zeichnung Expressivität. Der Unterschied zwischen Vorder- und Hintergrund tritt klar hervor.

This monochrome sepia drawing was made with the broad side of the crayon and then smudged. As a result, the figure has been pared down to its bare essentials. More pressure was put on the crayon to depict the darker creases.

Le dessin uni (ici en sépia) réalisé avec le côté large du pastel, puis l'estompage réduisent l'illustration à l'essentiel. Les plis plus sombres sont obtenus en appuyant plus fort sur le pastel.

Die einfarbige Gestaltung – hier in Sepia – mit der breiten Seite der Wachskreide und anschließendes Verwischen reduzieren diese Zeichnung auf das Wesentliche. Die Wachskreide wird fester aufgedrückt, um dunklere Falten zu erzeugen.

Here the artist decided against sharp
contours and applied the colour with just
the broad side of the crayon. If only one
colour is used, the volume is given more
emphasis.

Dans ce dessin, on a renoncé à un
contour net pour se contenter d'étaler la
couleur avec le côté large du pastel.
L'emploi d'une seule couleur met en
valeur le volume.

Hier wurde auf eine starke Konturierung
verzichtet und die Farbe nur mit der
breiten Kreideseite aufgetragen. Wird
nur eine Farbe verwendet, tritt das
Volumen in den Vordergrund.

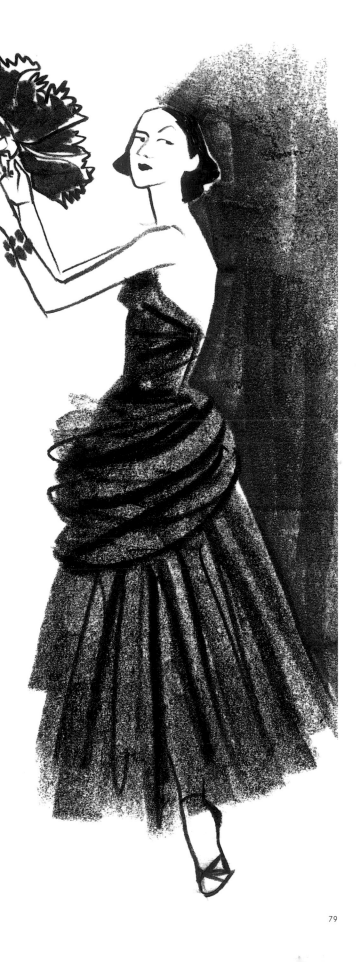

The broad side of the crayon is perfect for depicting more airy fabrics such as net lace or gauze. One example is this dress by the designer Charles James (1906–1978), who was known to reinterpret some of his older designs every year, paying no attention to the fashion industry's tradition of dividing the year into seasons.

Le côté large des pastels à l'huile se prête parfaitement à la représentation d'étoffes vaporeuses telles que le tulle ou la gaze. Cette robe du créateur Charles James (1906-1978) en est un parfait exemple ; le couturier s'est fait connaître en réinterprétant chaque année quelques-unes de ses anciennes esquisses sans tenir compte des saisons traditionnelles dans la mode.

Die breite Seite der Wachskreide eignet sich perfekt zur Darstellung luftiger Stoffe wie Tüll oder Gaze. Beispielhaft steht dieses Kleid des Designers Charles James (1906-1978), der bekannt dafür war, einige seiner älteren Entwürfe alljährlich neu zu interpretieren, ohne auf die traditionelle Saisoneinteilung der Modebranche Rücksicht zu nehmen.

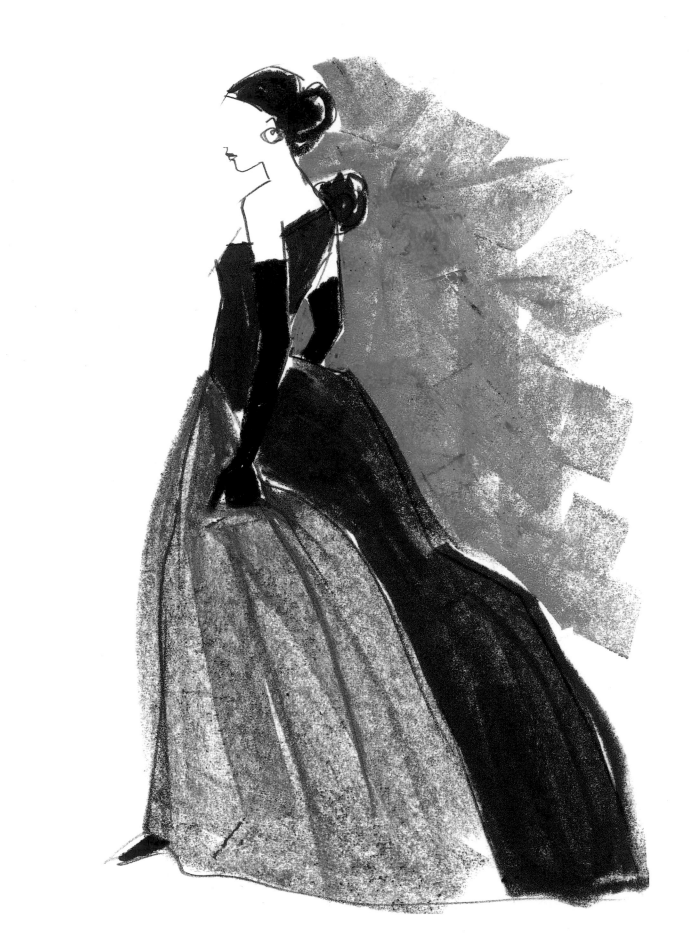

These two voluminous net lace dresses by Balenciaga were drawn using crayon with no pencil or outlines. In the first multicoloured illustration, just like in the second drawing where only two colours were used, depth is created by the accurate use of the broad side and edge of the crayon.

Ces deux amples robes en tulle de Balenciaga ont été directement dessinées avec des pastels à l'huile, sans trait préalable au crayon à papier ni contours. Sur la première esquisse, multicolore, comme sur la seconde, bicolore, la profondeur est obtenue en utilisant à bon escient le côté large et le côté pointu du pastel.

Diese beiden voluminösen Tüllkleider von Balenciaga wurden ohne Bleistift und Konturen nur mit Wachskreide angefertigt. Beim ersten, mehrfarbigen Entwurf wie auch beim zweiten, nur zweifarbigen Modell wird Tiefe durch den gezielten Einsatz der breiten und spitzen Kreideseite erzielt.

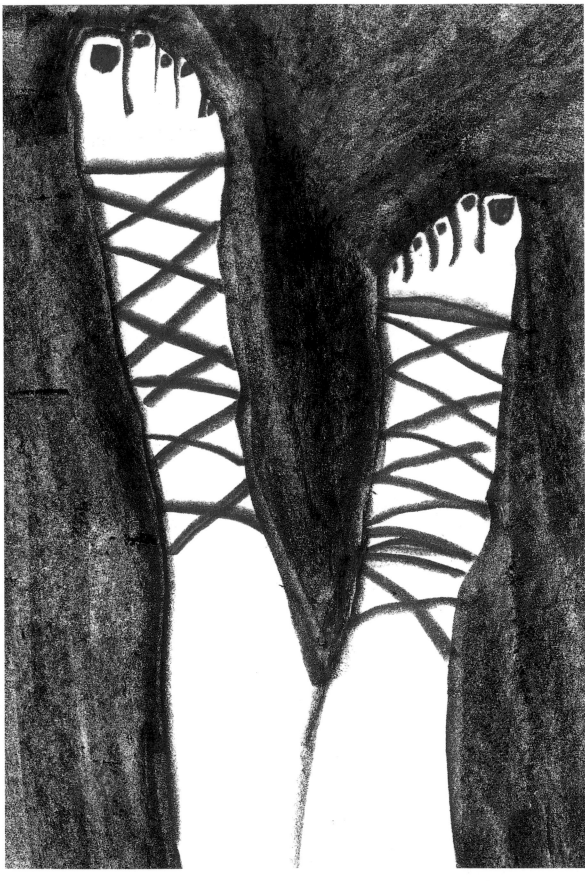

Dark, dense backgrounds make it possible to emphasise specific elements of a drawing, such as the feet and sandals in this illustration. The use of just two colours serves to intensify this effect.

Les fonds sombres et épais contribuent à faire ressortir certains éléments d'une illustration, ici les pieds et les sandales à brides. Le choix d'un dessin bicolore renforce encore cet effet.

Durch dunkle, dichte Hintergründe lassen sich gezielt Elemente einer Illustration hervorheben, wie hier die Füße und die Riemchensandalen. Die zweifarbige Gestaltung verstärkt diesen Effekt.

With just the tip of the crayon, accessories like these from the 1940s can be drawn with excellent results. At the time it was fashionable to apply makeup to the legs and then select matching shoes.

La pointe des pastels à l'huile est idéale pour représenter des accessoires comme ces chaussures des années 1940. C'était alors la mode de se peindre les jambes et de choisir des chaussures d'une couleur assortie.

Nur mit der Spitze der Wachskreide lassen sich hervorragend Accessoires wie diese Schuhe aus den vierziger Jahren des letzten Jahrhunderts zeichnen. Es war zu dieser Zeit in Mode, die Beine zu schminken und dazu farbig passende Schuhe auszuwählen.

This surprisingly realistic snakeskin dress is quite skilfully rendered thanks to the coarse-grained paper placed under the drawing paper and the use of the broad side of the crayon. This type of illustration appears much more realistic than a simple, two-dimensional drawing.

L'aspect de cette imitation de peau de serpent, qui ressemble à s'y méprendre à de la peau véritable, peut être rendu grâce à un papier au grain très épais placé sous la feuille de dessin et au côté large du pastel. Cette technique donne un résultat beaucoup plus réaliste qu'un simple dessin en deux dimensions.

Diese erstaunlich echt aussehende Schlangenlederimitation gelingt dank einem sehr grobkörnigen Papier unter dem Zeichenblatt und der Ausführung mit der breiten Kreideseite. Eine Darstellung wie diese wirkt sehr viel realistischer als eine einfache, zweidimensionale Zeichnung.

The texture of this cape-like jacket was evoked by placing a thin sheet of corrugated cardboard under the drawing paper and using the broad side of the crayon. The relief created in this way simulates ribbed fabrics such as ottoman, a thicker material with cross-ribbing.

La texture de cette cape courte est dessinée avec le côté large du pastel sur un support de fin carton ondulé. Le relief ainsi obtenu imite les étoffes côtelées tel l'ottoman, un tissu épais à côtes transversales.

Die Textur dieser Capejacke wird auf einem mit dünnem Wellkarton unterlegten Papier mit der breiten Kreideseite aufgetragen. Das so entstandene Relief imitiert gerippte Gewebe wie den Ottoman-Stoff, einen dicken Stoff mit Querrippen.

The soft texture of this fur was recreated with light and dark grey tones. Smudging the colours with the finger lends the model a warm, relaxed, confident appearance.

La texture délicate de cette fourrure a été obtenue à l'aide de deux tons de gris, un clair et un sombre. L'estompage des couleurs avec les doigts rend le vêtement douillet et savamment décontracté.

Die zarte Textur dieses Pelzes wurde mit einem hellen und dunklen Grauton erzielt. Das Verwischen der Farben mit den Fingern lässt das Modell warm und gekonnt lässig erscheinen.

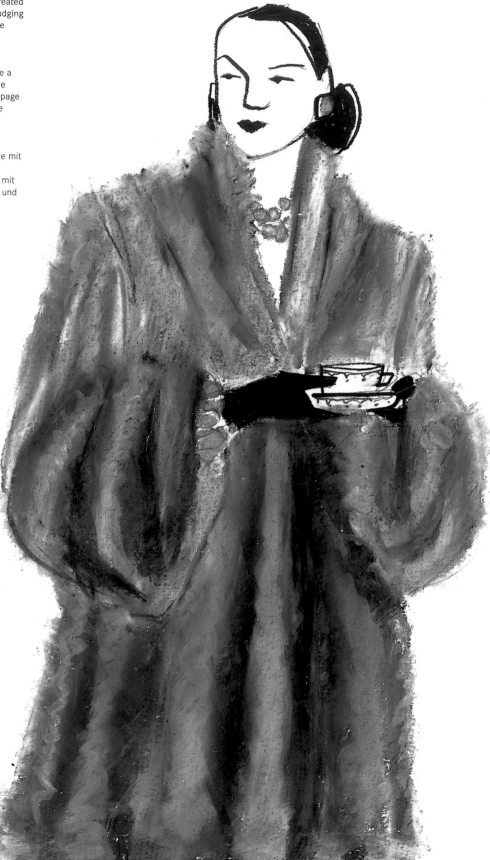

Fur can also be simulated without smudging the colours. The example here was made using the broad and sharper edge of a crayon and just two colours – black and grey. This drawing is much more expressive than the one opposite.

La fourrure peut aussi être représentée sans estompage avec les doigts. Dans cet exemple, elle a été dessinée avec le côté large et avec la pointe d'un pastel à l'huile dans les deux seules couleurs noir et gris. L'illustration est beaucoup plus expressive que celle de gauche.

Pelz lässt sich auch ganz ohne Verwischen mit den Fingern darstellen. Das gezeigte Beispiel wurde mit der breiten und der spitzen Seite einer Wachskreide und nur mit den zwei Farben Schwarz und Grau gestaltet. Diese Illustration wirkt viel ausdrucksstärker als die gegenüberliegende.

Wax crayons are best suited for depicting mixed fabrics. This wool material, for example, was created using ochre and green and almost without any smudging at all. The brown colour emphasises the folds and outlines.

Les pastels à l'huile conviennent parfaitement à la représentation des tissus chinés. Cette étoffe de laine a été reproduite avec des teintes ocres et vertes, presque sans aucun estompage avec les doigts. Le brun souligne les plis et les contours.

Wachskreide eignet sich am besten zur Darstellung gemischter Gewebe. Dieser Wollstoff beispielsweise entstand aus den Farben Ocker und Grün – nahezu ohne Verwischen mit den Fingern. Die braune Farbe betont Falten und Konturen.

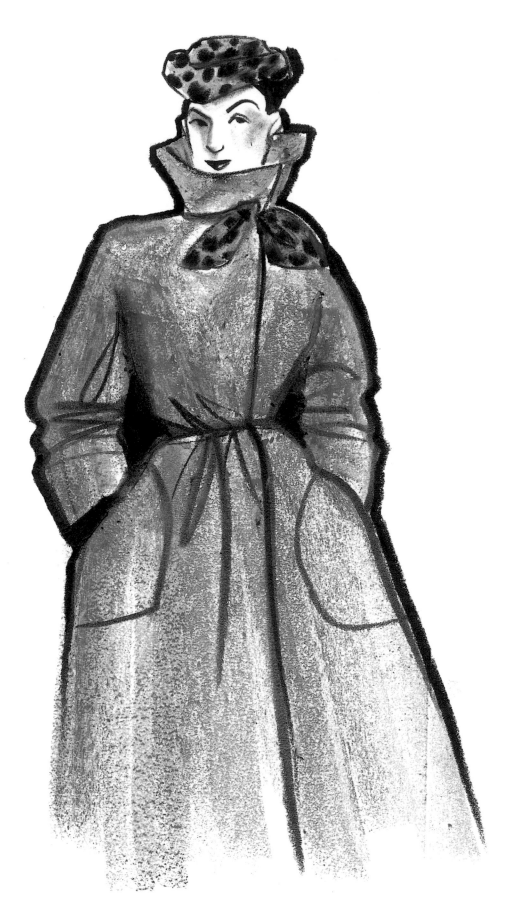

Wax crayons are also ideal for depicting transparent fabrics such as net lace. First the soft fabric is drawn as described above. Then the transparent layer is applied using the broad side of the crayon and with almost no smudging.

Les pastels à l'huile sont également recommandés pour les étoffes transparentes comme le tulle. Le tissage mat est d'abord représenté comme décrit plus haut et la couche transparente est ensuite appliquée par-dessus avec le côté large du pastel, sans estomper.

Auch für transparente Stoffe, wie Tüll, ist Wachskreide empfehlenswert. Zunächst wird das matte Gewebe wie bisher beschrieben gemalt, dann wird mit der breiten Seite der Wachskreide – ohne Verwischen – die transparente Schicht aufgetragen.

Knit fabrics, such as angora wool or mohair made from angora rabbit fur, as well as other fleecy fabrics, are usually depicted with crayon. These fabrics and textures are drawn in the same way as transparent materials.

Les vêtements à mailles, comme les tricots en laine angora produite à partir de fourrure de lapin angora ou en mohair, et autres tissages « moelleux » sont généralement représentés avec des pastels à l'huile. Ils sont réalisés de la même manière que les étoffes transparentes.

Strickstoffe, wie die aus Angorakaninchenfell gewonnene Angorawolle oder Mohair, und andere „flauschige" Gewebe werden meist mit Wachskreide dargestellt. Diese Stoffe und Texturen werden ebenso ausgearbeitet wie transparente Stoffe.

On this page you can see four drawings with completely different textures. The colours have been applied using the broad side of the crayon on course-grained watercolour paper to create a relief-like effect.

Les quatre esquisses de cette page ont des textures très différentes les unes des autres. Elles ont été dessinées avec le côté large du pastel sur du papier pour aquarelle à grain épais afin d'obtenir un effet de relief.

Auf dieser Seite sieht man vier Entwürfe mit völlig unterschiedlichen Texturen. Sie wurden mit der breiten Kreideseite auf grobkörnigem Aquarellpapier angelegt, um einen reliefartigen Effekt zu erzielen.

For more complex patterns, such as
plaids or argyles, both the sharper and
the broader edge of the crayon should
be used. The lines should not be
smudged or touched up.

Pour les tissus à motifs compliqués
comme l'écossais ou d'autres carreaux,
on utilise autant la pointe que le côté
large du pastel. Les traits ne sont ni
estompés, ni retouchés.

Für aufwändigere Stoffentwürfe, wie
Schotten- oder andere Karomuster,
bedient man sich sowohl der spitzen als
auch der breiten Seite der Wachskreide.
Die Striche werden nicht verwischt oder
nachgebessert.

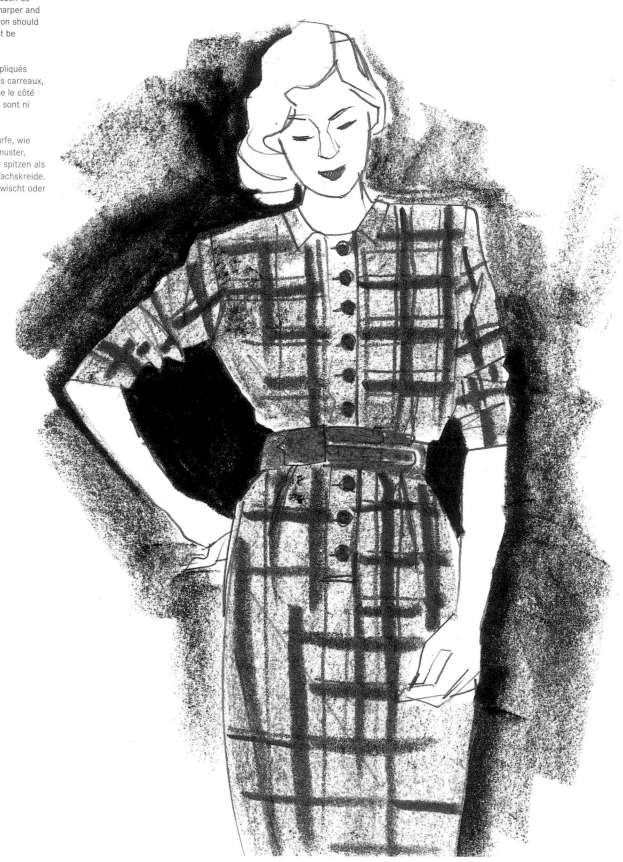

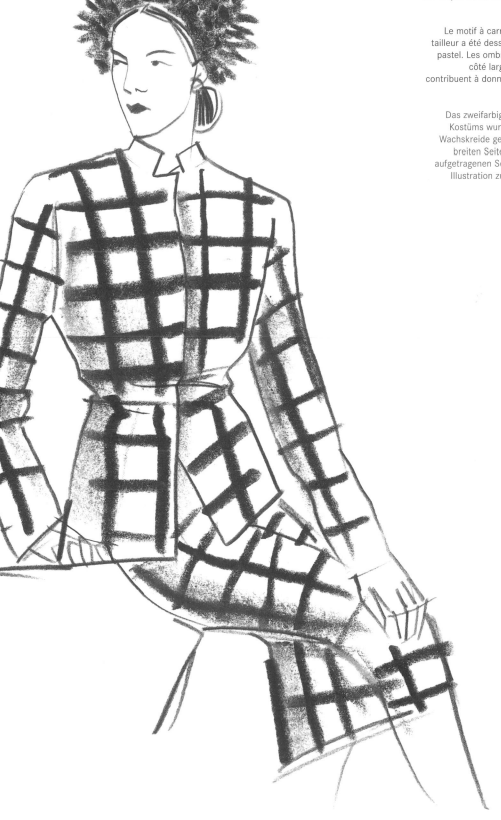

The two-tone chequered pattern on this dress was drawn with the edge of the crayon. The shading applied by pressing down lightly with the broader edge of the crayon lends volume and form to the illustration.

Le motif à carreaux bicolores de ce tailleur a été dessiné avec la pointe du pastel. Les ombres, obtenues avec le côté large sans trop appuyer, contribuent à donner volume et forme à l'illustration.

Das zweifarbige Karomuster dieses Kostüms wurde mit der Spitze der Wachskreide gezeichnet. Die mit der breiten Seite ohne starken Druck aufgetragenen Schatten verhelfen der Illustration zu Volumen und Form.

This traditional paisley design, which made the Scottish city of the same name famous in the 19th century, has been rendered using the edge of the crayon without applying much pressure. In some areas the pattern has not been completed, but has been made brighter or left completely white in order to show the light source.

Le motif traditionnel cachemire, ou Paisley, rendu célèbre au XIXe siècle par la ville écossaise du même nom, est dessiné avec la pointe du pastel sans trop appuyer. Certains motifs sont laissés inachevés ou plus clairs, voire blancs, pour figurer l'éclairage.

Das traditionelle Paisleymuster, das die gleichnamige schottische Stadt im 19. Jahrhundert bekannt machte, wird mit der Spitze der Wachskreide ohne starken Druck gezeichnet. Einige Stellen des Musters bleiben unvollendet oder werden heller, zum Teil weiß belassen, um den Lichteinfall anzudeuten.

This flower pattern was created in the same way as the paisley pattern on the opposite page, but the illustration on the right is more intense and uses stronger colours in the dark and shaded areas. Some areas, such as parts of the bow, were left white in order to show the folds.

Cette robe fleurie a été réalisée suivant la même technique que le motif cachemire de l'illustration de gauche, mais avec des couleurs plus intenses et appliquées avec plus de force dans les zones sombres. Certaines parties du ruban laissées en blanc représentent les plis.

Dieses Blumenmuster wurde auf die gleiche Art geschaffen wie das Paisleymuster auf der gegenüberliegenden Seite, allerdings zeigt die Illustration rechts eine höhere Intensität und einen kräftigeren Farbauftrag im dunklen bzw. schattierten Bereich. Einige Stellen wurden bei der Schleife weiß belassen, um die Falten anzudeuten.

As already demonstrated realistic illustrations can be created by drawing over a photocopy made on matte, grained (not glossy) paper. The areas of light and shade from the original should be coloured in in detail.

Comme on l'a vu plus haut, il est possible d'obtenir des dessins très réalistes en recouvrant de couleur une photocopie sur du papier mat et légèrement rugueux (pas du papier brillant). Pour cela, repasser sur les zones d'ombre et de lumière du modèle jusque dans le moindre détail.

Wie bereits gezeigt, lassen sich realistische Zeichnungen durch Übermalen einer Fotokopie auf mattem, körnigem Papier – nicht auf glänzendem – erzielen. Dazu werden die Licht- und Schattenbereiche der Vorlage bis ins Detail nachgezogen.

The method described above makes it possible to create impressive, realistic illustrations, thanks to the different uses of the crayon, including drawing with the edge or the broad side and smudging the crayon with the finger.

La technique décrite permet d'impressionnants dessins très réalistes, obtenus grâce aux différentes possibilités offertes par les pastels à l'huile : le tracé avec la pointe ou le côté large, et l'estompage avec les doigts.

Die beschriebene Technik erlaubt sehr eindrucksvolle, realistische Zeichnungen, die durch die verschiedenen Verwendungsmöglichkeiten der Wachskreide – das Zeichnen mit der spitzen oder breiten Seite und das Verwischen mit den Fingern – erreicht werden können.

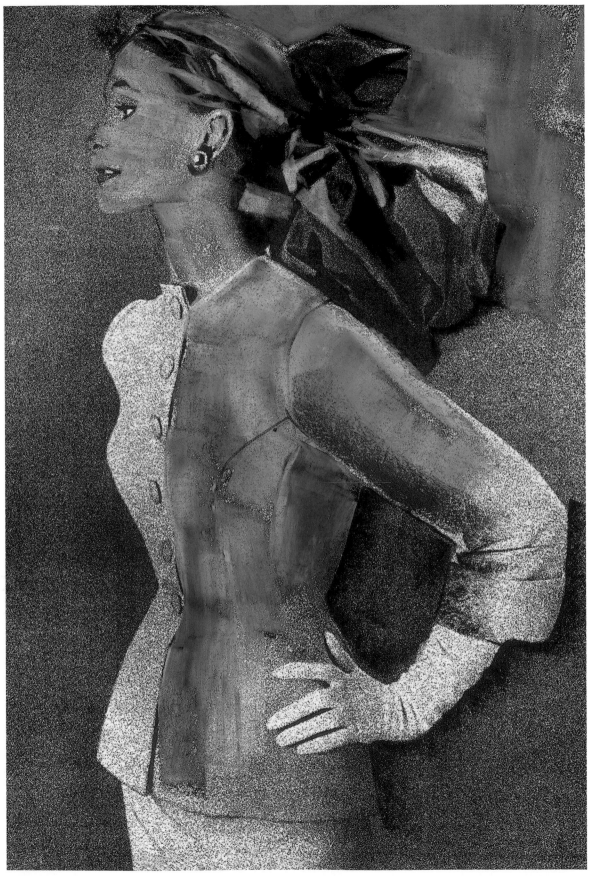

For illustrations of photographs, crayons are slowly applied, tracing the lines and surface shadows of the original

Pour les illustrations d'après des photographies, le pastel est appliqué progressivement sur le modèle en suivant les lignes et les surfaces d'ombre de l'original ...

Für Illustrationen nach Fotografien wird die Wachskreide entsprechend der Linien und Schattenflächen des Originals nach und nach auf die Vorlage aufgetragen, ...

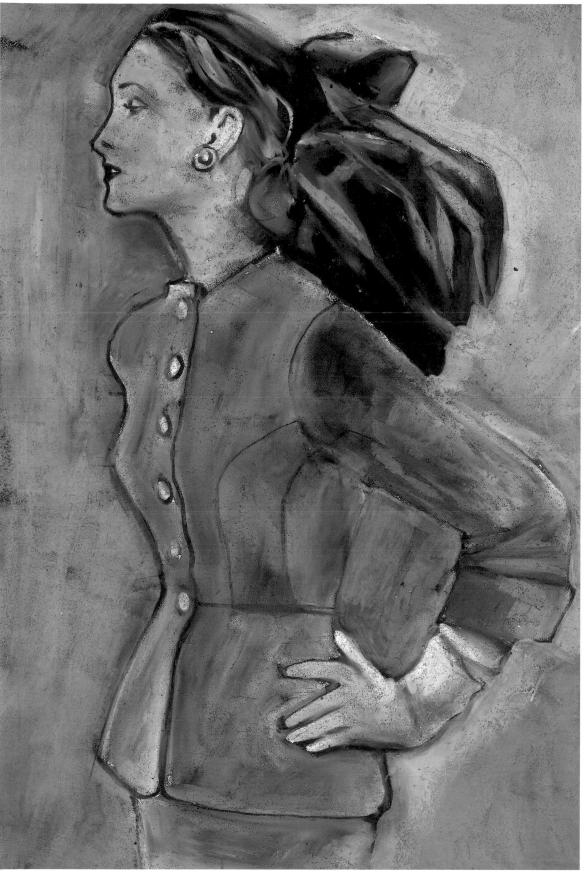

... until the picture has been completely coloured over, rendering a realistic illustration. It is best to keep the original photograph nearby to refer to as you colour over the picture.

... jusqu'à ce qu'il soit entièrement recouvert. L'image ainsi obtenue est très réaliste. Mieux vaut cependant garder une copie de l'original sous la main afin de pouvoir y jeter un coup d'œil pendant le travail.

... bis diese vollständig übermalt ist. So entsteht eine realistische Darstellung. Es ist ratsam, eine Kopie des Originals zur Hand zu haben, um während des Übermalens immer mal wieder einen Blick darauf werfen zu können.

Crayons are also ideal for drawing complex draping and shapes. This dress was drawn with three colours: light and dark grey, to show the different light sources, and black for the darker areas.

Les pastels à l'huile permettent de reproduire des drapés et des formes complexes. Cette robe a été représentée en trois couleurs : gris clair et gris foncé pour indiquer les différences d'éclairage, noir pour les zones sombres.

Wachskreide bietet sich zur Darstellung komplexer Faltenwürfe und Formen an. Dieses Kleid wurde mit drei Farben illustriert: Hell- und Dunkelgrau, um den unterschiedlichen Lichteinfall anzudeuten, und Schwarz für die dunklen Bereiche.

Trompe l'œil techniques, perspective and other optical effects can be employed. The boundaries between photography and realistic drawing are blurred, yielding optical illusions.

Grâce aux techniques de la peinture en trompe-l'œil, on obtient des perspectives et autres effets d'optique. Les frontières entre la photographie et le dessin réaliste s'estompent, l'observateur est berné.

Mit Techniken der Illusionsmalerei (Trompe l'œil) lassen sich perspektivische und andere optische Effekte erzielen. So verschwimmen die Grenzen zwischen Fotografie und realistischer Zeichnung, und das Auge des Betrachters wird getäuscht.

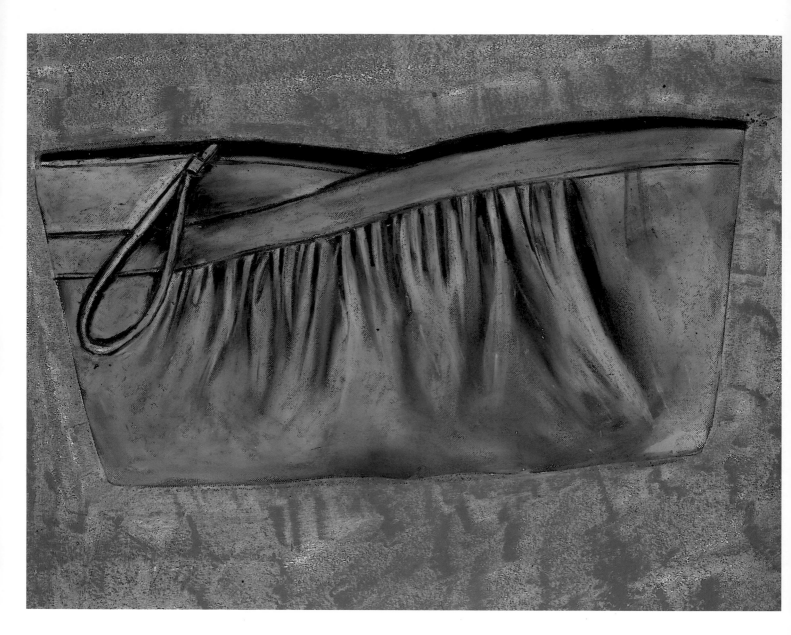

If a handbag and its textures are to be realistically illustrated, it should of course be drawn to life-size. The details in the foreground should be given more emphasis than those in the background, and shading should be created by applying deeper shades of the same colour.

Pour reproduire un sac et ses textures de manière réaliste, dessiner l'objet grandeur nature. Les détails du premier plan se détachent de l'arrière-plan et les ombres sont réalisées avec des tons plus foncés de la même couleur.

Soll eine Tasche und ihre Texturen realistisch abgebildet werden, sollte sie in natürlicher Größe gezeichnet werden. Dabei werden die Details im Vordergrund schärfer betont als im Hintergrund und die Schatten in dunkleren Tönen derselben Farbe aufgetragen.

Crayons have a high fat content. To produce them, pigments dissolved with essences and other substances are mixed into liquid wax. Wax crayons adhere better to the paper than other kinds of colouring utensils and allow for great expressiveness, as can be seen in the illustration of these shoes.

Les pastels à l'huile sont très gras. Ils s'obtiennent en mélangeant des pigments dissous dans la cire liquide à des essences et d'autres substances. Ils adhèrent bien mieux au papier que d'autres matières et permettent de donner du caractère aux objets, comme en témoignent ces chaussures.

Wachskreide ist stark fetthaltig. Bei der Herstellung werden in flüssigem Wachs gelöste Farben mit Essenzen und weiteren Substanzen gemischt. Sie haftet weitaus besser auf dem Papier als andere Farben und ermöglicht zudem eine große Ausdrucksstärke, wie diese Schuhe zeigen.

FELT-TIP PENS

LES FEUTRES / FASERSTIFTE

The felt-tip pen, a 1953 invention by the American Sidney Rosenthal, is a writing instrument with an ink source and a porous tip, usually made of felt or polyester fibre. The felt-tip pen is particularly suitable for producing monochromatic, clearly-outlined areas and is ideal for contemporary designs in luminous colours, in which the cut takes centre stage rather than the fabric texture.

Le feutre, inventé par l'Américain Sidney Rosenthal en 1953, se compose d'une mine à encre et d'une pointe poreuse, généralement en feutre ou fibres polyester. Il convient particulièrement aux surfaces unies clairement délimitées et se révèle idéal pour dessiner les modèles contemporains aux couleurs vives qui mettent moins l'accent sur la texture des étoffes que sur la coupe.

Der Faserstift, eine Erfindung des US-Amerikaners Sidney Rosenthal aus dem Jahr 1953, ist ein Schreibgerät mit Tintenmine und einer porösen, meist aus Filz oder Polyesterfaser bestehenden Spitze. Der Faserstift eignet sich besonders zur Gestaltung einfarbiger, klar abgegrenzter Flächen und ist ideal für zeitgenössische Entwürfe in leuchtenden Farben, bei denen weniger die Stofftextur als der Schnitt im Vordergrund steht.

Fine felt-tip pen
(0.4 mm
brushstroke
width)

Les feutres à
pointe fine
(largeur de trait
0,4 mm)

Feiner Faserstift
(0,4 mm
Strichbreite)

Fine felt-tip pens are exclusively used for detailed drawings.
Les feutres à pointe fine sont uniquement utilisés pour les détails.
Feine Faserstifte werden ausschließlich für Detailzeichnungen verwendet.

Medium-tip pen
(1.2 mm
brushstroke width)

Feutre à pointe
moyenne (largeur
de trait 1,2 mm)

Mittlerer Faserstift
(1,2 mm
Strichbreite)

With fine and medium-sized felt-tip pens, particular areas and details of an illustration can be highlighted.
Les feutres fins et moyens permettent de mettre en valeur certaines parties ou certains détails d'une illustration
Mit Faserstiften feiner und mittlerer Stärke können bestimmte Bereiche und Details einer Illustration hervorgehoben werden.

Medium-tip pen
(1.2 mm
brushstroke width)

Feutre à pointe
moyenne (largeur
de trait 1,2 mm)

Mittlerer Faserstift
(1,2 mm
Strichbreite)

This pen is perfect for free-flowing outlines.
Ce feutre permet de réaliser librement des contours flous.
Dieser Stift erlaubt eine lockere, freie Konturierung.

Medium-tip pen
(1.2 mm
brushstroke width)
Wide-tip marker
(7 mm brushstroke
width)

Feutre à pointe
moyenne (largeur
de trait 1,2 mm)
Feutre à pointe
large (largeur de
trait 7 mm)

Mittlerer Faserstift
(1,2 mm
Strichbreite)
Fasermaler (7 mm
Strichbreite)

For these drawings, a medium-sized felt-tip pen was used for the outlines and a wide-tip marker for the coloured areas.
Ces dessins ont été réalisés avec un feutre moyen pour les contours et un feutre large pour les surfaces.
Bei diesen Zeichnungen wurden ein Faserstift mittlerer Stärke für die Konturen und ein Fasermaler für die Farbflächen verwendet.

Brush pen
This pen is suitable for both simple depictions of clothing articles and accessories and for rendering transparent, diaphanous materials such as tulle.

Feutre-pinceau
Il convient autant à la représentation simplifiée de vêtements et d'accessoires qu'aux tissus transparents et vaporeux comme le tulle.

Pinselstift
Dieser Stift eignet sich sowohl für vereinfacht dargestellte Kleidungsstücke und Accessoires als auch für transparente, luftige Stoffe, wie Tüll.

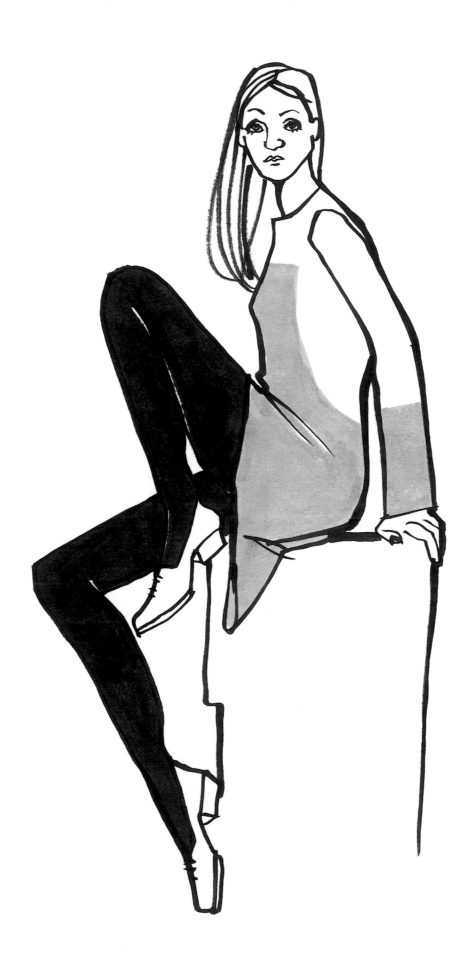

Felt-tip pens are good for colouring monochromatic areas. Here the ink was applied evenly up to the two narrow white folds at the waist. The outlines of the figure were thickened in black to set the dress and tights apart from each other and to emphasise the silhouette.

Le feutre permet de colorier facilement des surfaces unies. Dans cet exemple, la couleur a été appliquée uniformément partout, à l'exception d'un point peu éclairé dans les plis de la taille. Les contours ont été repassés en noir pour distinguer la robe des bas et mettre la silhouette en valeur.

Mit dem Faserstift lassen sich gut einfarbige Flächen schaffen. Hier wurde die Farbe bis auf einen schwachen Lichtpunkt an der Taillenfalte gleichmäßig aufgetragen. Die Konturen der Figur wurden schwarz nachgezogen, um Kleid und Strümpfe voneinander abzuheben und die Silhouette zu betonen.

These sketches were done in pure, luminous colours. The outline was reinforced in some places with a thick black stroke to give the figures depth and to highlight their silhouettes.

Ces esquisses ont été dessinées dans des couleurs pures et vives. Le profil a été accentué d'un épais trait noir à certains endroits pour donner de la profondeur aux personnages et souligner leur silhouette.

Diese Entwürfe wurden mit reinen, leuchtenden Farben ausgeführt. Das Profil wurde an einigen Stellen mit dickem, schwarzem Strich nachgezogen, um den Figuren Tiefe zu geben und ihre Silhouetten zu verstärken.

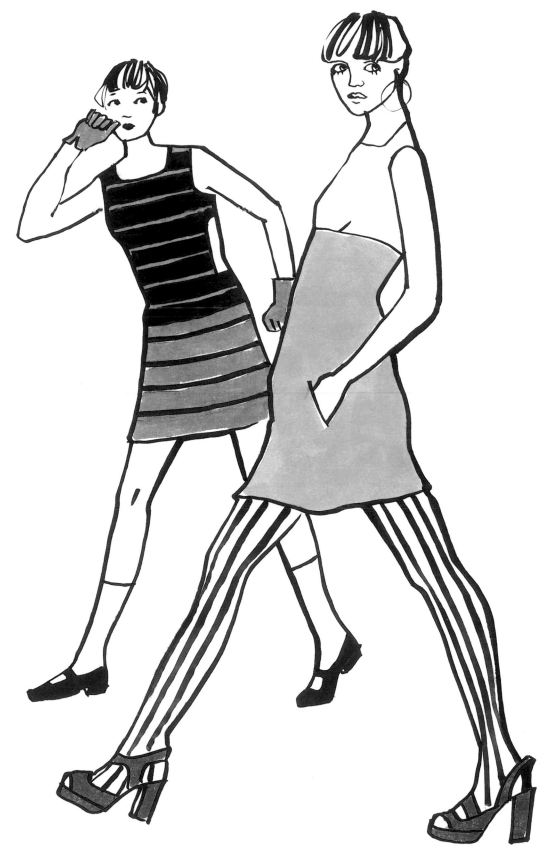

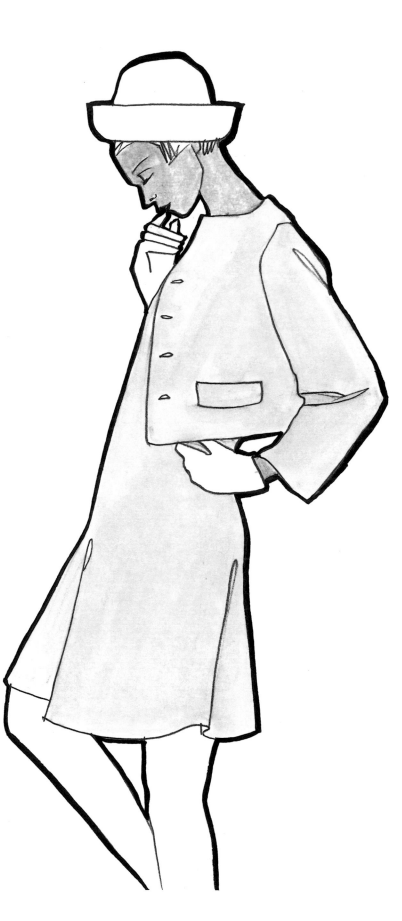

The outlines of this figure were drawn with a thick, black felt-tip pen and all other details with a pencil. The dress was coloured with a pastel blue felt-tip pen applied with little pressure so it appears more delicate than if a full-tone colour had been used.

Les contours du personnage ont été dessinés au feutre noir épais, tous les autres détails au crayon à papier. La robe coloriée en bleu pastel, sans écraser le feutre, ressort plus fine et délicate que ne la ferait paraître une teinte homogène.

Die Konturen dieser Figur wurden mit einem dicken schwarzen Faserstift, alle anderen Details mit einem Bleistift gezeichnet. Das Kleid wurde mit einem pastellblauen Faserstift ohne starken Druck ausgemalt, sodass es zarter wirkt als wenn eine Volltonfarbe benutzt worden wäre.

When outlines are drawn with a thick black felt-tip pen, an illustration appears far more expressive than with other drawing techniques. The other lines were added with a pencil to lend the figure further depth.

Les contours au feutre noir épais confèrent beaucoup plus d'expressivité à une illustration, caractéristique importante, que ne le permettent d'autres techniques de dessin. Les autres lignes sont ajoutées au crayon à papier afin de donner plus de profondeur au personnage.

Mit dickem schwarzen Faserstift gezeichnete Konturen lassen eine Illustration sehr viel ausdrucksstärker wirken als andere Zeichentechniken. Die übrigen Linien wurden mit dem Bleistift hinzugefügt, um der Figur mehr Tiefe zu verleihen.

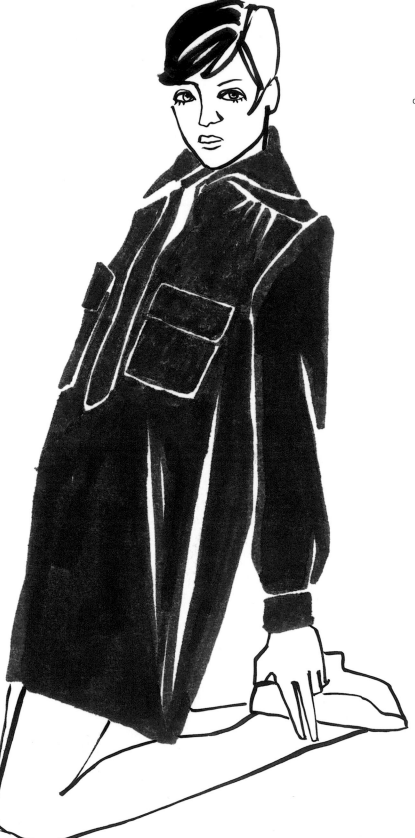

In this sketch, the folds of the dress were drawn with white lines. This technique is also used for placket pockets and the contrasting shaded areas.

Sur cette esquisse, les plis de la robe ont été suggérés par des traits blancs. La reproduction des poches plaquées et des zones d'ombre contrastées relève de la même technique.

Bei diesem Entwurf werden die Falten des Kleids mit weißen Streifen angedeutet. Diese Technik kommt auch bei den aufgesetzten Taschen und den kontrastierenden Schattenbereichen zur Anwendung.

The folds can also be drawn with a black felt-tip pen, which should have a brushstroke width of 1.2 mm or more, depending on the size of the illustration. This example shows a dress from the private collection of Twiggy, the famous 1960s model.

Les plis peuvent être également dessinés au crayon-feutre noir, d'une épaisseur de trait de 1,2 mm ou plus selon le format de l'illustration. L'exemple montre une robe de la collection privée de Twiggy, le célèbre mannequin des années 1960.

Die Falten können auch mit einem schwarzen Faserstift aufgetragen werden, der je nach Größe der Illustration eine Strichbreite von 1,2 mm oder mehr aufweisen sollte. Dieses Beispiel zeigt ein Kleid aus der Privatkollektion von Twiggy, dem berühmten Model der 1960er Jahre.

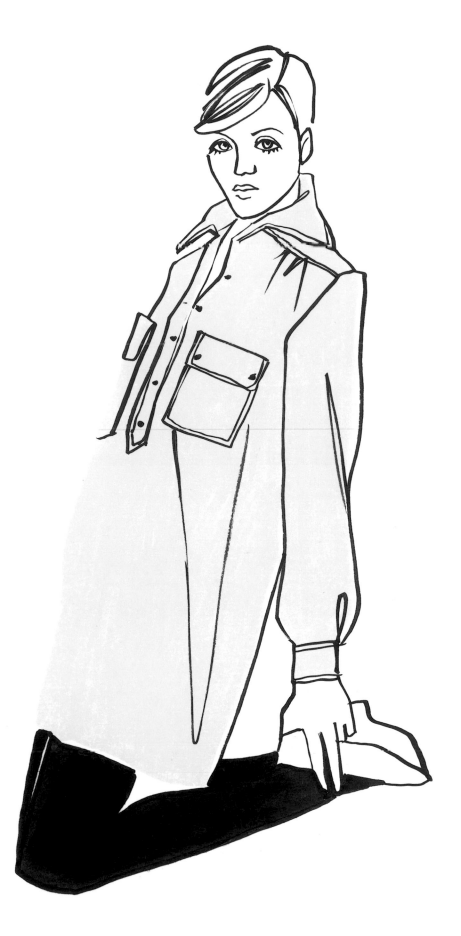

A pencil sketch by Emilio Pucci (1914–1992), in which only some parts are accentuated in colour. The head, neck and left arm remain uncoloured and fade into the background, so that the eye is only directed to the coloured areas.

Esquisse au crayon à papier d'Emilio Pucci (1914-1992), dont quelques parties sont rehaussées par de la couleur. La tête, le cou et le bras gauche restent clairs et en retrait, de sorte que le regard se porte uniquement sur les zones coloriées.

Ein Bleistiftentwurf von Emilio Pucci (1914-1992), bei dem nur einige Teile farblich hervorgehoben werden. Kopf, Hals und linker Arm bleiben hell und treten in den Hintergrund, sodass der Blick des Betrachters ausschließlich auf die kolorierten Stellen gelenkt wird.

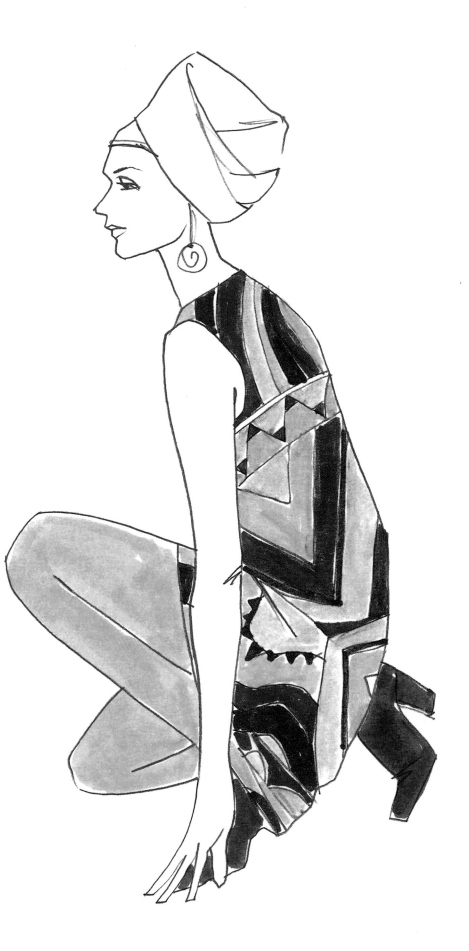

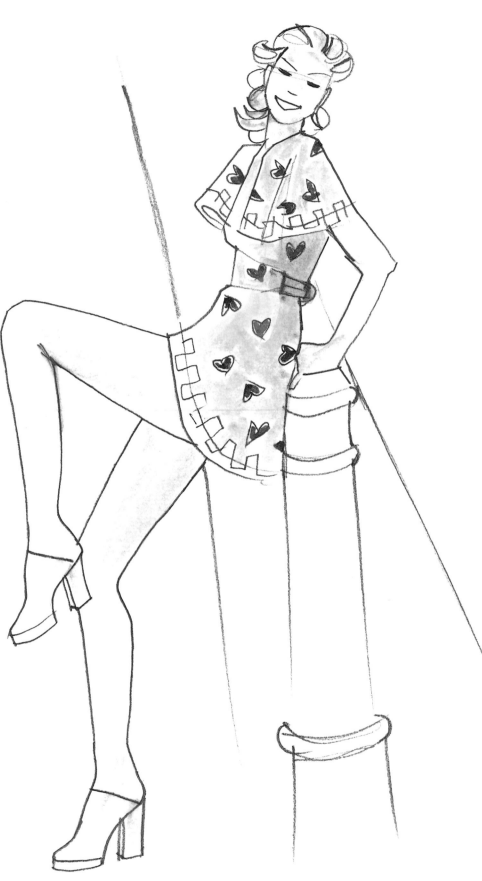

This pencil sketch by Ossie Clark (1942–1996), one of the most influential British couturiers of the 1960s, shows a mini-dress in pastel tones applied with the light strokes of a felt-tip pen. The visible pencil lines lend the model extra liveliness.

Cette esquisse au crayon à papier d'Ossie Clark (1942-1996), l'un des grands couturiers britanniques les plus influents des années 1960, représente une mini-jupe dans des tons pastel appliqués au crayon-feutre sans trop appuyer. Les lignes de crayon à papier laissées visibles rendent le personnage plus vivant.

Dieser Bleistiftentwurf von Ossie Clark (1942-1996), einem der einflussreichsten britischen Couturiers der 1960er Jahre, zeigt ein Minikleid in Pastelltönen, die ohne großen Druck mit einem Faserstift aufgetragen wurden. Die sichtbaren Bleistiftlinien lassen das Modell lebendiger erscheinen.

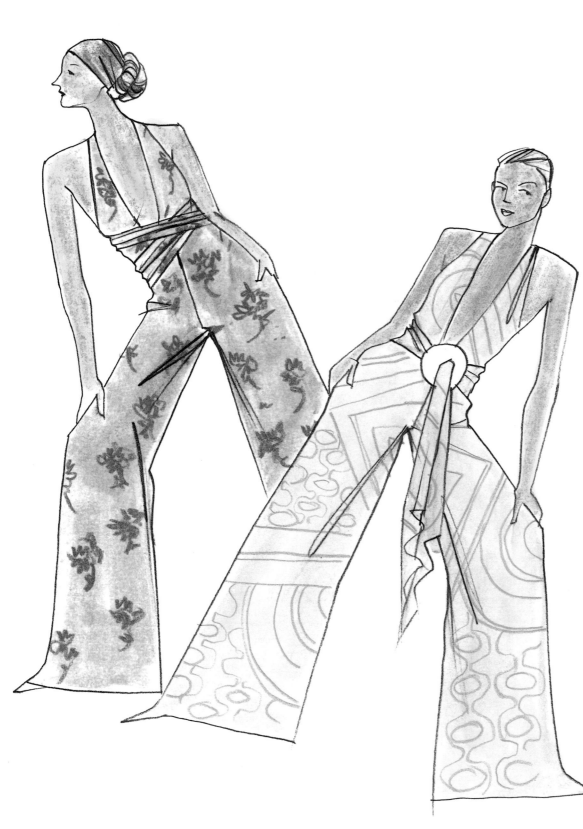

The use of several different techniques within one illustration gives it variety and interest. The figures were sketched in pencil and the fabric painstakingly portrayed with felt-tip pens in pastel tones. Finally, the fabric pattern was applied in coloured pencil. The result is a compelling illustration in which all the drawing techniques fully harmonise with each other.

L'association de différentes techniques pour une même illustration la fait paraître plus variée et plus intéressante. Les personnages sont préalablement dessinés au crayon à papier et le tissu est simplement évoqué au feutre dans des tons pastel, puis les motifs sont réalisés aux crayons de couleur. On obtient ainsi une illustration très expressive. Toutes les techniques sont en parfaite harmonie.

Der Einsatz verschiedener Techniken innerhalb einer Illustration lässt sie abwechslungsreich und interessant wirken. Die Figuren wurden mit Bleistift vorgezeichnet und der Stoff mit Faserstift in Pastelltönen zart ausgeführt. Das Stoffmuster wurde schließlich mit Buntstiften aufgetragen. Das Ergebnis ist eine ausdrucksstarke Illustration, in der alle Zeichentechniken wohl aufeinander abgestimmt sind.

When, as here, artistic draping must be depicted, first draw the figure in pencil and then fill it out with delicate felt-tip pen colours. Afterwards, the fabric folds and strands of hair are depicted using coloured pencils. The outline on the right was made uneven and thick using a black felt-tip pen.

Pour représenter, comme ici, des drapés savants, commencer par dessiner la silhouette au crayon à papier avant de la remplir de couleurs délicates au feutre. Les plis du tissu et les mèches de cheveux sont ensuite esquissés au crayon de couleur. Pour finir, repasser irrégulièrement les contours du côté droit au feutre noir.

Wenn wie hier kunstvolle Faltenwürfe dargestellt werden sollen, zeichnet man die Figur zunächst mit Bleistift vor und füllt sie dann mit Faserstiften in zarten Farben aus. Danach werden die Stofffalten und die Haarsträhnen mit Buntstift angedeutet. Abschließend zieht man die Konturen rechts mit einem schwarzen Faserstift unregelmäßig nach.

Felt-tip pens are best used for rendering smooth, plain fabric. The picture shows several designs in the so-called Halston style, which is characterised by a whole range of conceptual principles: simply cut trousers and pullovers or traditional shirt dresses with close-fitting waists.

Les feutres conviennent particulièrement à la représentation de tissus lisses sans motifs. On voit ici plusieurs esquisses dans le style d'Halston qui se distingue par plusieurs principes conceptuels : pantalons et pull-overs de coupe simple ou robes-chemisiers traditionnelles à la taille ajustée.

Faserstifte eignen sich am besten zur Gestaltung glatter, ungemusterter Stoffe. Das Bild zeigt mehrere Entwürfe im so genannten Halston-Stil, der sich durch eine Reihe konzeptueller Prinzipien auszeichnet: einfach geschnittene Hosen und Pullover oder traditionelle Hemdblusenkleider mit eng anliegender Taille.

The play of light is indicated by white highlights on these trouser combinations. The warm-coloured wide stripe pattern on the lower part of the left model's trousers was created with a felt-tip pen. The visible pencil marks also serve to intensify the expressive quality of the illustration.

L'éclairage, figuré par des zones laissées en blanc, rehausse l'éclat du deux-pièces pantalon de droite. Les larges chevrons du bas de pantalon de gauche ont été coloriés aux feutres de couleur. L'esquisse au crayon à papier visible par-dessous rend ce dessin particulièrement expressif.

Der Lichteinfall, der durch weiße Stellen angedeutet wird, zeigt sich als Glanzlichter auf dieser Hosen-Kombination. Das breite Streifenmuster in warmen Farben am unteren Hosensaum des linken Modells ist mit einem Faserstift ausgeführt worden. Der sichtbare Bleistiftentwurf dient auch hier als besonderes Ausdrucksmittel.

These designs by Frowick Halston (1932–1990), perhaps the first international fashion star, were rendered in loose outlines using a felt-tip pen. The main focus lies more in the volume and draping than in the details.

Ces esquisses de Frowick Halston (1932-1990), probablement la première star internationale de la mode, se caractérisent par un contour imprécis au feutre. Le dessinateur a accordé la plus grande attention davantage au volume et au drapé qu'aux détails.

Diese Entwürfe von Frowick Halston (1932-1990), dem vielleicht ersten internationalen Modestar, basieren auf einer lockeren Konturierung mit dem Faserstift. Das Hauptaugenmerk liegt weniger auf den Details als vielmehr auf Volumen und Faltenwurf.

Brush pens lend themselves to illustrations that aim to convey verve and dynamism, like this one. This can be achieved by long, broad strokes and loose outlines, which is exemplified by these clothes made with a plain, silky fabric.

Le feutre-pinceau est particulièrement indiqué pour les illustrations qui, comme ici, doivent donner une impression de vigueur et de dynamisme obtenus par de longs traits larges et des contours flous. Ces robes en tissu soyeux uni en fournissent un excellent exemple.

Der Pinselstift bietet sich an bei Illustrationen, die Schwung und Dynamik vermitteln sollen, wie diese Kleider aus seidigem, einfarbigem Stoff beispielhaft zeigen. Hierzu wird der Stift in langen, breiten Strichen und lockerer Konturierung aufgetragen.

This illustration was also made with a brush pen. Thanks to the very soft tip, the line thickness can change by altering the pressure, so wafer-thin lines as well as stripes up to 1 cm wide can be drawn.

Cette illustration a elle aussi été réalisée au feutre-pinceau. La pointe extrêmement souple permet de varier la largeur du trait selon la pression pour obtenir des lignes très fines, mais aussi des raies faisant jusqu'à 1 cm de largeur.

Auch diese Illustration wurde mit dem Pinselstift angefertigt. Dank der äußerst weichen Spitze lässt sich die Strichstärke durch unterschiedlichen Druck variieren, und so können hauch-dünne Linien, aber auch bis zu 1 cm breite Streifen gezeichnet werden.

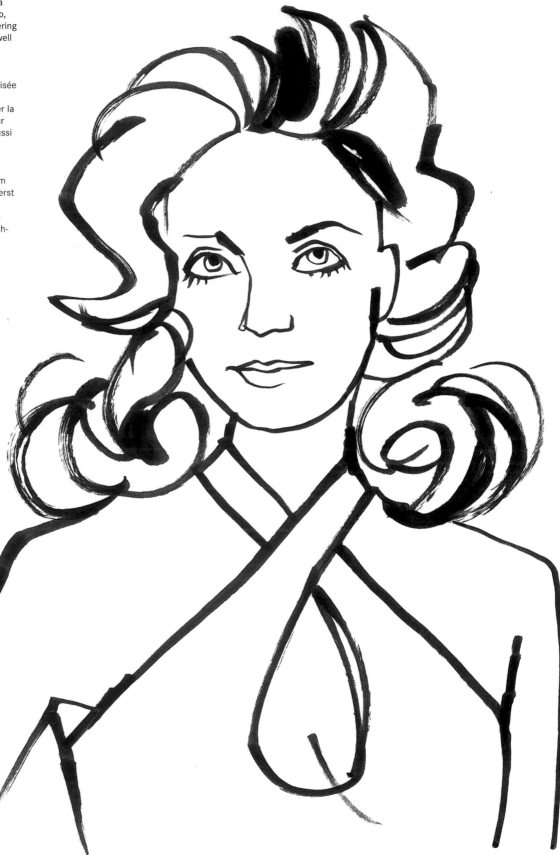

By varying the pressure and the tilt of the brush pen, lines of differing thicknesses can be achieved. However, a steady hand and sensitivity are required, as the line thickness changes with even the slightest pressure.

Selon la pression exercée sur le feutre-pinceau et son inclinaison, on obtient des lignes plus ou moins larges. Calme et doigté sont cependant de rigueur pour cette technique car l'épaisseur du trait change au moindre mouvement un peu plus appuyé.

Je nach Druck und Neigungswinkel lassen sich mit dem Pinselstift unterschiedlich breite Linien ausführen. Eine ruhige Hand und Fingerspitzengefühl sind allerdings geboten, da sich die Strichstärke schon bei leichtem Druck verändert.

This illustration was created with a 3-mm-thick felt-tip pen. Pens of this size are best suited for expressive monochromatic drawings, in which the eye should be drawn to fabric details or the pattern.

Voici une illustration réalisée avec un feutre d'une pointe de 3 mm. Ces largeurs de trait sont idéales pour les modèles unis très expressifs ou bien ceux dont des détails de l'étoffe ou le motif doivent capter le regard.

Diese Illustration wurde mit einem 3 mm dicken Faserstift ausgeführt. Stifte dieser Stärke eignen sich am besten für einfarbige, ausdrucksstarke Zeichnungen, bei denen der Blick des Betrachters auf Stoffdetails oder das Muster gelenkt werden soll.

Following the motto of the French filmmaker and comic Jacques Tati, who believed that too much colour distracts an audience, here a black-and-white illustration was produced with a 3-mm-thick felt-tip pen. In this way, the model's pose and the contours of the clothing come to the fore.

Dans l'esprit du réalisateur et comique français Jacques Tati, pour qui « trop de couleur nuit au spectateur », cette illustration a été exécutée dans un seul ton, avec un feutre de 3 mm. La pose du mannequin et les contours du vêtement sont ainsi au centre de l'attention.

Ganz nach dem Motto des französischen Filmregisseurs und Komikers Jacques Tati, dass zu viel Farbe den Zuschauer ablenkt, wurde hier eine einfarbige Illustration mit einem 3 mm dicken Faserstift gezeichnet. Die Pose des Models und die Konturen der Kleidung geraten so in den Fokus des Betrachters.

For fashion illustrations using felt-tip pens, often merely two colours are used and applied in different thicknesses – a minimalist approach produces an impressive effect.

Les illustrations de mode au feutre se limitent souvent à deux couleurs dans différentes largeurs de trait. Cette manière de réduire le dessin au strict minimum fait très bel effet.

Oft werden bei Modeillustrationen mit Faserstift lediglich zwei Farben verwendet und mit unterschiedlichen Strichbreiten aufgetragen. Durch eine solche Reduktion aufs Wesentliche lässt sich eine eindrucksvolle Wirkung erzielen.

This illustration, which shows a dress by Halston, the Andy Warhol of couturiers, was pared down to the bare essentials with just two colours and two different line thicknesses. The monochrome background featuring broad red strokes brings the model more strongly into the foreground.

Cette illustration, une robe d'Halston, l'Andy Warhol de la haute couture, a été limitée à l'essentiel avec seulement deux couleurs et deux largeurs de trait différentes. Le fond uni appliqué en traits larges fait encore plus ressortir le personnage.

Diese Illustration, die ein Kleid von Halston, dem Andy Warhol unter den Couturiers, zeigt, wurde mit nur zwei Farben und zwei verschiedenen Strichbreiten aufs Essentielle beschränkt. Der einfarbige Hintergrund aus breiten Strichen lässt das Model stärker hervortreten.

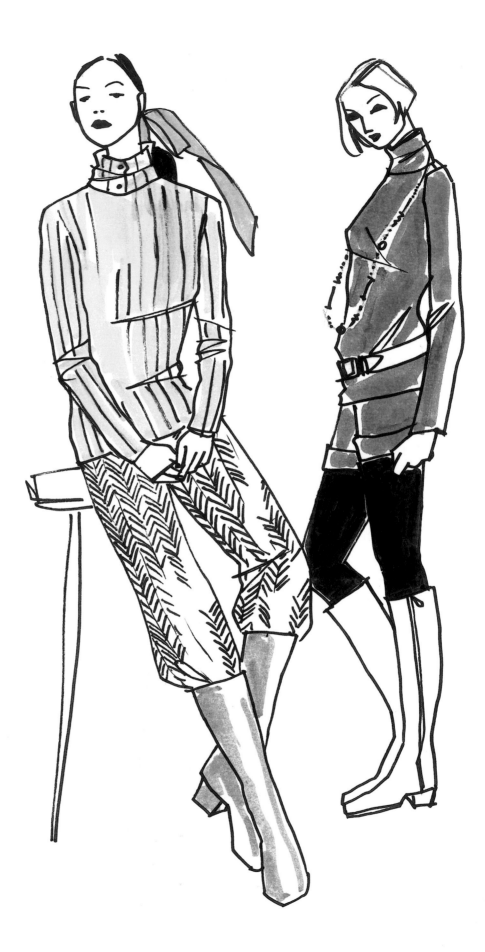

Thin felt-tip pens are mostly used, as shown here, for details such as fabric patterns, buttons or zips, or for accessories such as belts and necklaces.

Les traits de feutres plus fins sont généralement utilisés pour les détails (par exemple le tissage, les boutons ou fermetures-éclair) ou pour les accessoires, tels que ceinture, motifs ou bijoux.

Dünnere Faserstifte werden zumeist, wie hier gezeigt, für Details, etwa Gewebemuster, Knöpfe oder Reißverschlüsse, oder für Accessoires, wie Gürtel, Muster und Halsketten, eingesetzt.

Motion can be drawn with felt-tip pens, lending the figure dynamism and panache. Here, movement in the shoulder and knee areas is indicated.

Le feutre permet aussi de dessiner très simplement des lignes de mouvement qui confèrent une grande vitalité à un personnage, comme ici les mouvements suggérés au niveau de l'épaule et du genou.

Mit dem Faserstift lassen sich auch recht einfach Bewegungslinien zeichnen, die einer Figur Dynamik und Schwung verleihen. Hier wird Bewegung im Schulter- und Kniebereich angedeutet.

Ruffles, as in this design by Halston, are mostly drawn with very thin felt-tip pens, such as 0.4 mm thick. The colour, however, is delicately applied without any pressure with a wide felt-tip pen. The areas left white on the figure indicate light.

Les volants, comme sur cette esquisse de Halston, sont le plus souvent dessinés au feutre à pointe très fine, par exemple de 0,4 mm. La couleur, en revanche, est appliquée au feutre large avec soin et sans appuyer. Les parties laissées en blanc indiquent l'éclairage.

Rüschen, wie in diesem Entwurf von Halston, werden meist mit sehr dünnen Faserstiften, beispielsweise 0,4 mm stark, gezeichnet. Die Farbe hingegen wird mit einem breiten Faserstift ohne Druck zart aufgetragen. Die weiß belassenen Stellen der Figur deuten den Lichteinfall an.

Short strokes made with very thick markers, such as those used in graffiti art, are good for depicting feathers. The dress in this illustration has no outlines in order to hint at its feathery lightness.

Les plumes sont faciles à représenter avec des feutres très épais, tels ceux utilisés pour les graffitis artistiques, et des traits courts. L'absence de contours sur la robe de cette illustration suggère mieux sa « légèreté de plume ».

Mit sehr dicken, in der Graffiti-Kunst üblichen Faserstiften und kurzen Strichen lassen sich gut Federn darstellen. Das Kleid in dieser Illustration besitzt keine Konturen, um seine „Feder Leichtigkeit" anzudeuten.

For detailed drawings, use the thinnest
felt-tip pen possible. Thick felt-tip pens,
in contrast, are more suitable for
shading and any parts of the illustration
that do not require particular precision.

Pour les dessins aux nombreux détails,
choisir un feutre le plus fin possible. Les
feutres plus épais, au contraire,
conviennent mieux aux zones d'ombres
et aux éléments qui ne requièrent
aucune précision particulière.

Bei detailreichen Zeichnungen sollte man
einen möglichst dünnen Faserstift
verwenden. Dickere Faserstifte hingegen
eignen sich besser für Schatten und alle
Bildelemente, die keine besondere
Präzision erfordern.

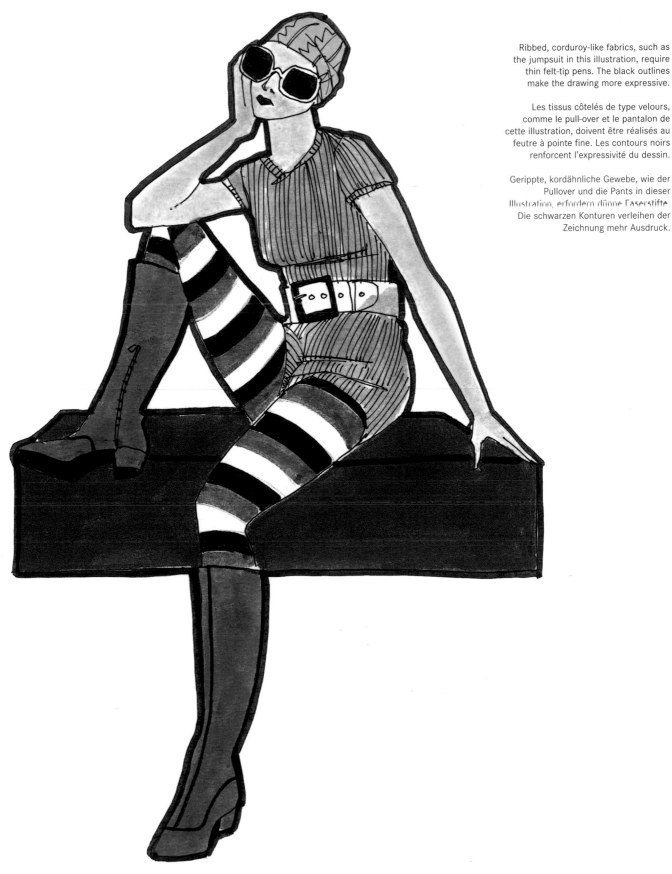

Ribbed, corduroy-like fabrics, such as the jumpsuit in this illustration, require thin felt-tip pens. The black outlines make the drawing more expressive.

Les tissus côtelés de type velours, comme le pull-over et le pantalon de cette illustration, doivent être réalisés au feutre à pointe fine. Les contours noirs renforcent l'expressivité du dessin.

Gerippte, kordähnliche Gewebe, wie der Pullover und die Pants in dieser Illustration, erfordern dünne Faserstifte. Die schwarzen Konturen verleihen der Zeichnung mehr Ausdruck.

The lines on the striped pattern of this shirt dress are sometimes interrupted to show light reflections. The same effect can also be achieved with bright lines, putting less pressure on the felt-tip pen.

Le motif rayé de cette robe-chemisier présente des lignes interrompues qui marquent l'éclairage. Le même effet peut être obtenu avec des lignes plus claires : il suffit pour cela d'appuyer moins fort sur le feutre.

Das Streifenmuster dieses Hemdblusenkleids weist unterbrochene Linien auf, die den Lichteinfall zeigen. Dieselbe Wirkung lässt sich auch mit helleren Linien erzielen – der Faserstift wird dafür schwächer aufgedrückt.

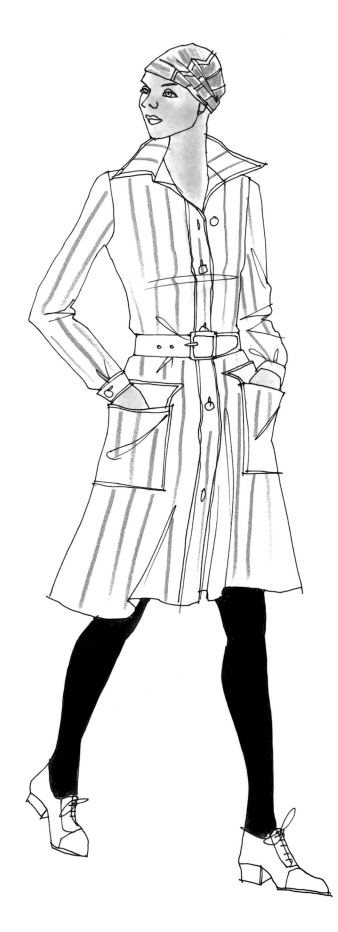

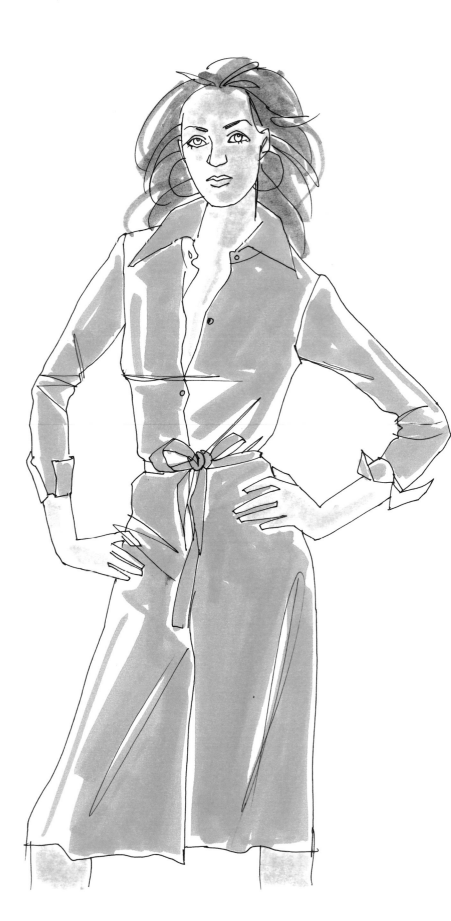

This figure was sketched in pencil. The white areas reflect the light falling on the shiny, silky dress. The typical blow-dried hairstyle of the 1970s with its carefully tended, fluffy layered cut, is rendered with a few bold strokes and subsequent colouring.

Le personnage a d'abord été dessiné au crayon à papier. Les parties en blanc figurent la lumière qui tombe sur la robe de tissu lisse et soyeux. Le brushing typique des années 70 avec coupe en dégradé souple est obtenu à l'aide de quelques traits marqués, suivis d'un coloriage.

Diese Figur wurde mit Bleistift vorgezeichnet. Die weißen Stellen reflektieren den Lichteinfall auf dem Kleid aus glattem, seidigem Stoff. Die typische Föhnfrisur der 1970er Jahre mit gepflegtem, lockerem Stufenschnitt entsteht durch einige markante Striche und anschließende Kolorierung.

When depicting transparent material, the figure is first drawn in pencil and then the skin colour is applied with the flat end of a felt-tip pen. Finally, the clothing is coloured in the desired tone without exerting too much pressure on the felt-tip pen.

Pour les tissus transparents, commencer par dessiner le personnage au crayon à papier et appliquer ensuite la couleur de la peau avec la pointe plate d'un feutre. Puis, le vêtement est colorié dans la couleur voulue sans trop appuyer sur le feutre.

Sollen transparente Stoffe dargestellt werden, wird zunächst die Figur mit dem Bleistift vorgezeichnet und dann die Hautfarbe mit der flachen Spitze eines Faserstifts aufgetragen. Abschließend wird ohne allzu starken Druck auf den Faserstift das Kleidungsstück im gewünschten Ton koloriert.

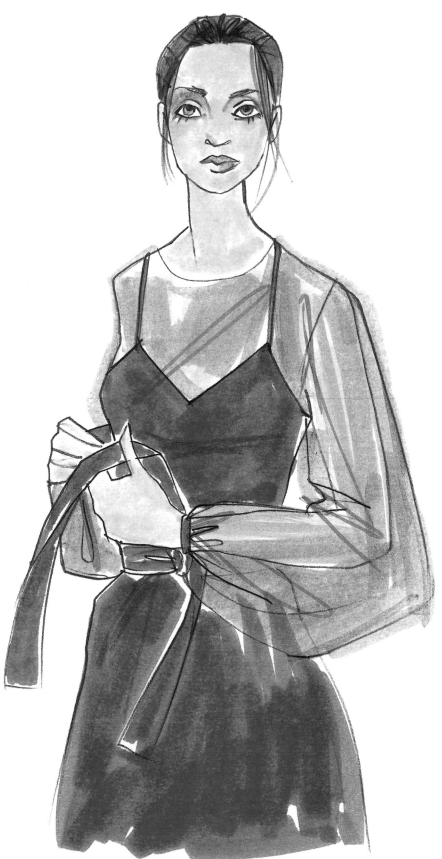

Transparency can also be achieved with two felt-tip pens of the same colour in different shades. The lighter tone is used for the transparent material, whereas the darker tone depicts the opaque material and the folds.

Il est également possible de figurer la transparence à l'aide de deux feutres de la même couleur mais de nuances différentes. La teinte la plus claire est utilisée pour le tissu transparent et la plus sombre pour le tissu opaque et le drapé.

Transparenz lässt sich auch mit zwei Faserstiften derselben Farbe in verschiedenen Schattierungen erzielen. Der hellere Farbton wird für das transparente Gewebe verwendet, der dunklere für den opaken Stoff und den Faltenwurf.

These designs by Angelo Tarlazzi (b. 1942), the "Italian designer with the strongest Parisian flair", as he was referred to in the 1960s and 1970s, show shading and folds in grey. Press the felt-tip pen very lightly on the paper to achieve the effect shown here.

Ces esquisses d'Angelo Tarlazzi (né en 1942), appelé dans les années 60 et 70 « le plus parisien des créateurs italiens », présentent des effets d'ombres et de plis en gris. On obtient ce genre de résultat en appuyant très légèrement le feutre sur le papier.

Diese Entwürfe von Angelo Tarlazzi (geboren 1942), dem „italienischen Designer mit dem stärksten Pariser Flair", wie man ihn in den 1960er und 1970er Jahren nannte, zeigen Schatten- und Falteneffekte in grauer Farbe. Der Faserstift sollte nur ganz leicht auf das Papier gedrückt werden, will man die hier gezeigte Wirkung erzielen.

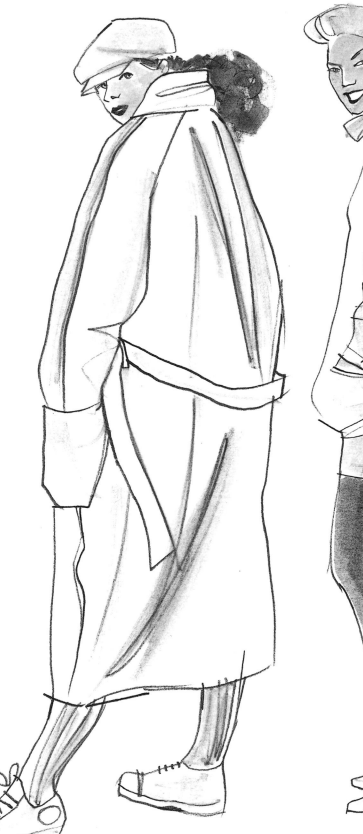

When depicting a shadow or a fold, the desired spot is highlighted in grey. The uncoloured areas show where the light falls. A good example is this sketch by Azzedine Alaïa.

Pour représenter une ombre ou un pli, on commence généralement par marquer l'éclat en gris à l'endroit voulu. Les zones non coloriées indiquent l'éclairage. Cette esquisse d'Azzedine Alaïa illustre bien la technique choisie.

Wenn ein Schatten oder eine Falte gezeigt werden soll, werden an der gewünschten Stelle zumeist in Grau Glanzlichter aufgetragen. Die unkolorierten Stellen zeigen den Lichteinfall. Ein gutes Beispiel ist dieser Entwurf von Azzedine Alaïa.

To illustrate rather simple or less detailed materials or accessories, such as the shoes shown here, first generously apply the colour of the object with a wide-tip marker, then draw the outlines with a graphite pencil.

Pour les matériaux ou accessoires sobres, comportant peu de détails, comme ces chaussures, on peut commencer par un aplat de couleur de l'objet à représenter, avant d'en dessiner les contours au crayon graphite.

Sollen eher schlichte oder wenig detaillierte Materialien oder Accessoires, zum Beispiel die hier gezeigten Schuhe, dargestellt werden, kann man mit dem Fasermaler zunächst einen flächigen Farbauftrag des abzubildenden Gegenstands machen. Anschließend werden dann mit einem Graphitstift die Konturen des Objekts gezeichnet.

Wide-tip markers are best suited for depicting clearly defined, clear-cut patterns, like the classic 1970s motifs in Marimekko style. They are also the best bet for checks, simple stripes and other bold patterns.

Les feutres à pointe large conviennent le mieux pour les motifs clairement délimités, aux contours nets, notamment les motifs classiques des années 70 dans le style Marimekko. Ils sont également parfaits pour les carreaux, rayures simples et autres motifs basiques.

Ein Fasermaler eignet sich bestens zur Darstellung klar definierter, scharf umrissener Muster, wie die klassischen Motive im Marimekko-Stil der 1970er Jahre. Auch Karos, einfache Streifen und andere grob gestaltete Muster gelingen perfekt.

PENCILS

LES CRAYONS / STIFTE

The pencil is a writing implement with graphite lead embedded in a wooden shaft. In contrast to ballpoint or ink pens, marks made by pencils can be easily erased or corrected. There are different kinds of pencil, and they are usually categorised according to their degree of hardness: extremely hard pencils yield thin, delicate lines, whereas extremely soft pencils produce thick, dark strokes.

Le crayon à papier se compose d'une mine en graphite dans un corps en bois. À la différence du stylo à bille ou à encre, son trait peut facilement être effacé et corrigé. Il existe différents types de crayons à papier, généralement classés selon la dureté de leur mine : les plus durs, ou secs, donnent des traits fins et légers, les plus gras des traits épais et foncés.

Der Bleistift ist ein Schreibgerät mit einer Graphitmine, die in einen Holzschaft eingebettet ist. Anders als bei Kugel- oder Tintenschreibern lässt sich der Bleistiftstrich leicht ausradieren oder korrigieren. Es gibt unterschiedliche Arten von Bleistiften, die meist nach Härtegrad unterteilt werden: sehr harte Bleistifte ergeben dünne, zarte Striche, sehr weiche dicke und dunkle.

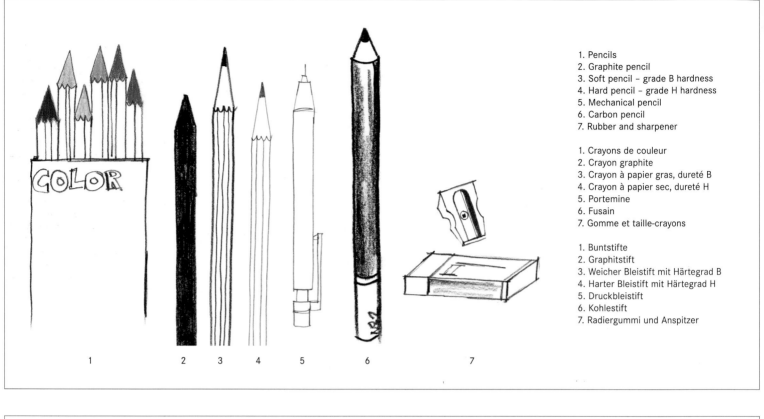

1. Pencils
2. Graphite pencil
3. Soft pencil – grade B hardness
4. Hard pencil – grade H hardness
5. Mechanical pencil
6. Carbon pencil
7. Rubber and sharpener

1. Crayons de couleur
2. Crayon graphite
3. Crayon à papier gras, dureté B
4. Crayon à papier sec, dureté H
5. Portemine
6. Fusain
7. Gomme et taille-crayons

1. Buntstifte
2. Graphitstift
3. Weicher Bleistift mit Härtegrad B
4. Harter Bleistift mit Härtegrad H
5. Druckbleistift
6. Kohlestift
7. Radiergummi und Anspitzer

Pencils with grade H hardness
Hard pencils (grade H) contain more clay than graphite. They last longer than soft pencils, but the marks they make are fainter. Such pencils are thus best suited for illustrations with many details, such as seams, ridges or patterns.

Crayon à papier dureté H
Dans les crayons à papier secs (dureté H), la proportion d'argile est supérieure à celle de graphite. Ils durent plus longtemps que les crayons gras et leurs traits sont moins marqués. Par conséquent, ils conviennent surtout aux illustrations présentant de nombreux détails, comme les coutures apparentes, les côtes ou les motifs.

Bleistift mit Härtegrad H
Harte Bleistifte (Härtegrad H) besitzen einen höheren Ton- als Graphitanteil. Sie halten länger als weiche Bleistifte, die Striche dagegen sind schwächer. Bleistifte eignen sich daher am besten für Illustrationen mit vielen Details, wie zum Beispiel Sichtnähten, Rippen oder Mustern.

Mechanical pencils
Mechanical or retractable pencils contain a plastic or metal casing with different-sized lead – 0.3, 0.5 or 0.7 mm. They are easy to use because the size of the lead remains constant. When a piece of lead has been used up, it can be replaced by a new one.

Portemine
Le portemine, ou crayon mécanique, se compose d'un corps en plastique ou en métal contenant des mines d'un diamètre de 0,3 mm, 0,5 mm ou 0,7 mm. Il est très agréable à utiliser car on peut toujours avoir la même longueur de mine ; lorsqu'elle est usée, il suffit de la remplacer par une autre.

Druckbleistift
Der Druckbleistift, auch mechanischer Stift, besitzt ein Kunststoff- oder Metallgehäuse und enthält Minen unterschiedlicher Stärke von 0,3 mm, 0,5 mm oder 0,7 mm. Seine Handhabung ist sehr angenehm, da die Minenlänge beim Zeichnen leicht nachreguliert werden kann. Ist eine Mine aufgebraucht, wird sie durch eine neue ersetzt.

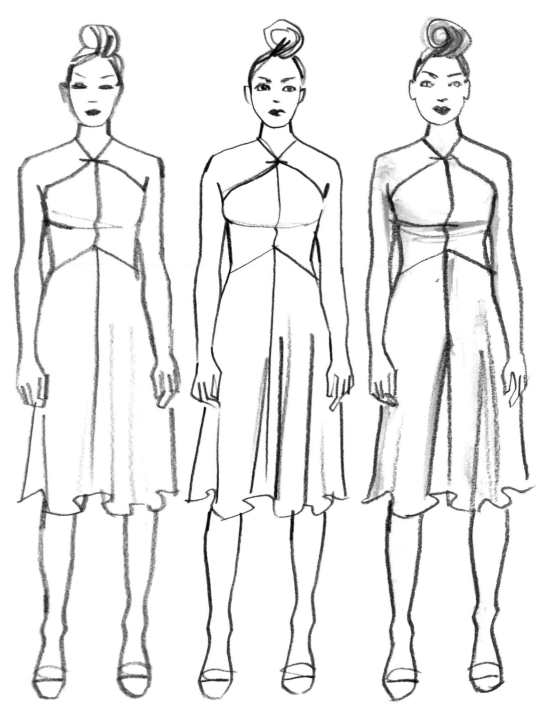

Graphite pencils with thick lead
These usually have soft lead with a diameter of around 5 mm.
Charcoal
In contrast to pencils, charcoal is not encased in a wooden shell. It is nevertheless sharpened with a standard sharpener.
Watercolour pencils
The colour is applied with a wet brush onto a surface similar to watercolour paper.

Crayon graphite à mine épaisse
En général, il renferme une mine grasse de 5 mm de diamètre environ.
Crayon fusain
À la différence du crayon à papier, le crayon fusain n'est pas entouré de bois. Il se taille cependant lui aussi avec un taille-crayons standard.
Crayon aquarelle
La couleur appliquée au crayon aquarelle est ensuite étalée avec un pinceau humide pour obtenir l'effet caractéristique de l'aquarelle.

Graphitstift mit dicker Mine
Er besitzt für gewöhnlich eine weiche Mine mit rund 5 mm Durchmesser.
Zeichenkohle
Anders als Bleistifte ist die Zeichenkohle nicht von einem Holzschaft ummantelt. Sie wird jedoch ebenfalls mit einem Standard-Anspitzer gespitzt.
Aquarellstift
Die damit aufgetragene Farbe wird mit einem feuchten Pinsel zu einer aquarellähnlichen Fläche verstrichen.

Realistic shading can be created if the unlighted areas of the picture are hatched with a hard pencil. This shading should not be smudged with the finger or cotton, but should only be made by hatching.

Des effets d'ombres réalistes sont obtenus en hachurant avec un crayon à papier sec les zones de l'image opposées à la lumière. Les hachures suffisent, il n'est pas nécessaire d'estomper l'ombre avec les doigts ou du coton.

Realistische Schatteneffekte entstehen, wenn mit einem harten Bleistift die vom Licht abgewandten Bildbereiche schraffiert werden. Diese Schatten werden nicht durch das Verwischen mit den Fingern oder Watte, sondern ausschließlich durch Schraffuren erzeugt.

Shading can also be done with a very soft pencil or charcoal. In this case, the hatching should be rubbed with the finger or a piece of cotton until the right size and darkness has been produced.

L'ombre peut aussi être réalisée avec un crayon à papier très gras ou un crayon fusain et en frottant les hachures avec les doigts ou un morceau de coton jusqu'à l'obtention d'une ombre de la teinte et de la taille voulues.

Schatten lassen sich auch mit einem sehr weichen Bleistift oder mit Zeichenkohle erzielen, indem man die Schraffuren mit den Fingern oder etwas Watte so lange verreibt, bis ein Schatten in der gewünschten Tönung und Größe entsteht.

Light can best be rendered in a drawing by means of good light-dark contrast. Shadows should be made as dark as possible, while the areas receiving direct light should be left white.

Pour représenter un certain éclairage, le mieux est d'avoir recours à un contraste clair-obscur très marqué. Les zones d'ombres sont réalisées dans la teinte la plus sombre possible, tandis que les surfaces éclairées sont laissées en blanc.

Der Lichteinfall in einer Abbildung lässt sich am besten durch einen ausgeprägten Hell-Dunkel-Kontrast darstellen. Die Schatten werden möglichst dunkel angelegt, während die vom Licht getroffenen Partien weiß belassen werden.

Skilful depictions of light and shadow make drawings more realistic. Between the light and shaded areas, there should also be half-shadows, produced by muted light. They can be suggested by gentle strokes or by hatching with a hard pencil.

Les dessins paraissent plus réalistes lorsque la représentation de l'ombre et de la lumière est réussie. Entre les zones sombres et les zones claires se trouve ce que l'on appelle la pénombre, produite par une lumière tamisée. Elle est suggérée par des traits légers ou des hachures au crayon à papier sec.

Eine gelungene Darstellung von Licht und Schatten lässt Zeichnungen realistischer wirken. Zwischen den Licht- und Schattenbereichen liegen so genannte Halbschatten, die durch gedämpftes Licht entstehen. Sie werden durch zarte Striche oder Schraffuren mit einem harten Bleistift angedeutet.

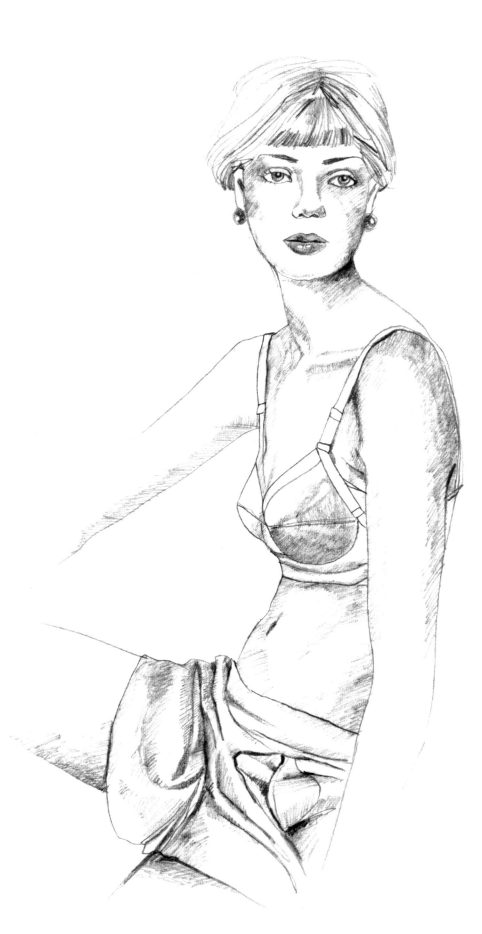

Graphite pencils with thick lead are particularly well-suited for schematic drawings using even strokes. In these drawings, fabric patterns, textiles, accessories and other details should not be depicted.

Les crayons graphite à mine épaisse conviennent particulièrement aux représentations schématiques, au tracé régulier, dans lesquelles ni le motif de l'étoffe, ni le tissage, les accessoires ou tout autre détail ne sont soulignés.

Graphitstifte mit dicker Mine eignen sich besonders gut für schematische Zeichnungen mit gleichmäßiger Strichführung, in denen weder Stoffmuster, noch Textilgewebe, Accessoires oder sonstige Details betont werden.

Feathers and similar materials are best drawn using a soft pencil. The disadvantage of this method is the lack of detail, although this is usually not required with such articles of clothing.

Les plumes et matières similaires sont dessinées au crayon à papier gras. Cette technique présente cependant l'inconvénient d'une précision insuffisante, même si elle suffit généralement à ce type de vêtement.

Federn und ähnliche Materialien zeichnet man mit einem weichen Bleistift. Der Nachteil dieser Technik ist die mangelnde Detailgenauigkeit, die jedoch bei derartigen Kleidungsstücken meist nicht erforderlich ist.

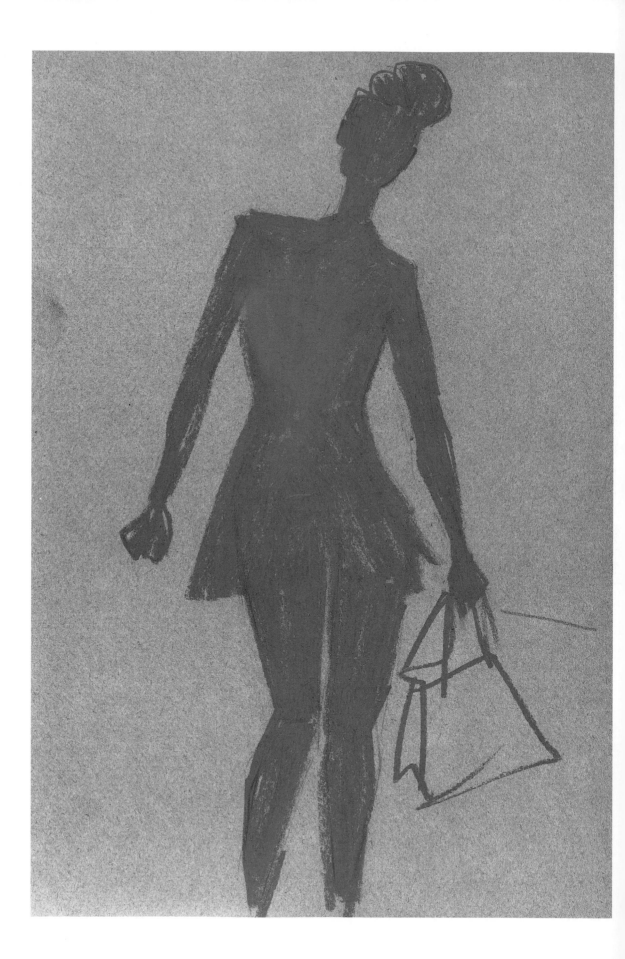

Graphite can be used to create very vivid effects, especially in larger drawings. A large format should be used if the illustration is to contain much detail, as the lines can become quite thick.

Les illustrations au crayon graphite ont souvent l'air floues et peu nettes, les formes grossièrement esquissées. Le fond, ici, a été estompé avec les doigts ou un morceau de coton et les silhouettes ont été repassées au crayon à papier.

Illustrationen, die mit Graphit angefertigt werden, wirken unscharf und verschwommen, die Formen nur grob angedeutet. Der Hintergrund wurde jeweils mit den Fingern oder Watte verwischt, die Silhouetten mit dem Bleistift nachgezeichnet.

Graphite generally allows for more casual, thicker and effortless strokes. Softer lead allows for greater freedom of expression and can render figures more expressively, although details are much more difficult to render than they are with hard leads.

Le crayon graphite permet un tracé léger, souple et vigoureux. Les mines grasses donnent une grande liberté de composition pour des personnages plus expressifs, mais les détails sont beaucoup plus difficiles à dessiner qu'avec les mines sèches.

Graphit ermöglicht generell eine lockere, kräftige und ungezwungene Strichführung. Weiche Minen erlauben große Gestaltungsfreiheit und lassen Figuren ausdrucksstark wirken, allerdings sind Details damit wesentlich schwieriger zu zeichnen als mit harten Minen.

The general rule of thumb for fashion illustrations is: the thicker the strokes, the less detailed the drawing. The technique should be chosen according to the purpose of the drawing or which elements or features are to be emphasised.

Selon une règle fondamentale, valable pour les illustrations de mode en général, plus le trait est épais, moins le dessin est précis. La technique picturale dépend donc avant tout de l'intention, c'est-à-dire des éléments ou des caractéristiques que l'on souhaite souligner ou mettre particulièrement en évidence.

Die allgemeine Grundregel für Modeillustrationen lautet: je kräftiger der Strich, desto weniger detailliert die Zeichnung. Die Zeichentechnik richtet sich daher ausschließlich danach, welche Intention ein Entwurf verfolgt beziehungsweise welche Elemente oder Merkmale in den Vordergrund gerückt werden sollen.

Very different effects can be produced depending on the angle at which the graphite pencil is held in relation to the paper. The outlines of articles of clothing can be drawn darker if the volume of the figure so requires.

On obtient des effets très différents selon l'angle avec lequel le crayon graphite est tenu par rapport au papier. Les contours des vêtements peuvent être assombris par endroits pour mieux rendre le volume du corps.

Es lassen sich sehr unterschiedliche Effekte erzielen, je nach dem in welchem Winkel der Graphitstift zum Papier gehalten wird. Die Konturen von Kleidungsstücken werden dort etwas dunkler gestaltet, wo es das Volumen der Figur erfordert.

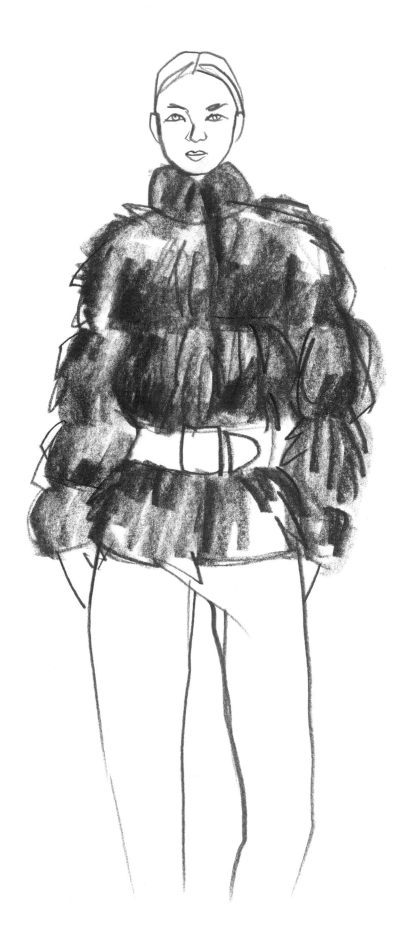

Fur can also be drawn with a soft coloured pencil. Here the texture of the bolero has been rendered with a brown coloured pencil moved in a slightly diagonal direction. The pattern of the dress was rendered using a black pencil with an intermediate grade of hardness.

Il est également possible de représenter la fourrure avec un crayon de couleur gras. La texture de ce boléro a été esquissée avec un crayon marron tenu presque verticalement, tandis que les motifs de la robe ont été réalisés au crayon noir de dureté moyenne.

Pelz lässt sich auch mit einem weichen Buntstift darstellen. Hier wurde die Textur des Boleros mit einem leicht schräg geführten braunen Buntstift angedeutet. Das Muster des Kleides wurde mit einem schwarzen Stift mittleren Härtegrades ausgeführt.

Hard pencils with thinner lead that have a high percentage of clay are well-suited for detailed drawings, such as ornate patterns. Generally speaking, the drawing appears fainter than it would if it were made using a soft pencil, but it is also much more precise.

Les crayons à papier secs à la mine fine, à forte proportion d'argile, conviennent bien aux reproductions très détaillées, par exemple de motifs complexes. Le dessin dans l'ensemble est plus pâle que s'il avait été réalisé avec un crayon à papier gras, mais il est aussi plus précis.

Harte Bleistifte mit dünner Mine, die einen hohen Tonanteil haben, eignen sich gut für detaillierte Darstellungen, beispielsweise aufwändige Muster. Die Zeichnung wirkt insgesamt blasser als wenn sie mit einem weichen Bleistift ausgeführt worden wäre, dafür besitzt sie jedoch größere Präzision.

Hard pencils are also excellent for conveying motion. The figure shown here was drawn with casual, light strokes that in some areas, such as the elbows and knees, go beyond the contours, suggesting motion.

Le crayon à papier sec est également préférable pour rendre les mouvements. Le personnage ci-contre a été dessiné à traits légers et souples qui débordent à certains endroits, notamment aux coudes et aux genoux, ce qui lui confère plus de vitalité.

Auch zur Wiedergabe von Bewegungen sind harte Bleistifte empfehlenswert. Die hier abgebildete Figur wurde mit lockeren, leichten Strichen gezeichnet, die an einigen Stellen, etwa Ellbogen und Knien, über die Konturen hinausgehen und Dynamik andeuten.

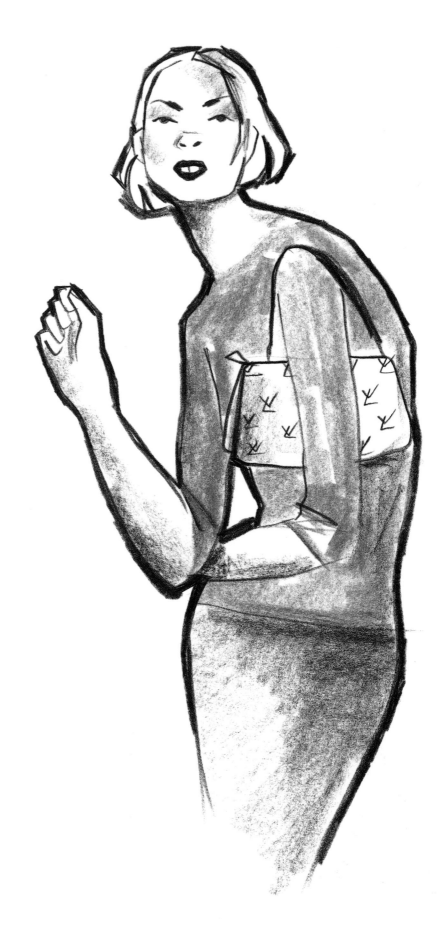

For both illustrations, a basic colour was applied with a soft coloured pencil and then smudged. The surfaces that were left white suggest light. In both figures, the outlines were drawn darkly, lending the drawings expressiveness.

Sur ces deux illustrations, une teinte unie a été appliquée au crayon de couleur gras, puis estompée. Les surfaces laissées en blanc marquent l'éclairage. Les contours sont dans les deux cas très prononcés pour obtenir un dessin plus expressif.

Bei beiden Illustrationen wurde mit einem weichen Buntstift jeweils ein einfarbiger Grundton angelegt, der anschließend verwischt wurde. Die hell belassenen Flächen deuten den Lichteinfall an. Die Konturen sind bei beiden Figuren kräftig gezeichnet und verleihen den Zeichnungen so Ausdruck.

A drawing does not have to be fully coloured. If only a single detail or element is to be highlighted, such as the turtleneck sweater in the drawing to the left or the stockings in the drawing to the right, partial colouring is a suitable technique. The combination of coloured pencils of different strengths makes the illustration to the left seem particularly detailed and elaborate.

Nul besoin de colorier entièrement une illustration. Le coloriage partiel est un bon moyen de mettre en valeur un seul élément, comme le pull à col roulé sur l'illustration de gauche ou les bas sur celle de droite. L'association de crayons de couleurs de diverses épaisseurs donne à l'illustration de gauche une finition très détaillée et particulièrement soignée.

Eine Zeichnung muss nicht unbedingt komplett koloriert sein. Soll nur ein bestimmtes Detail oder Element hervorgehoben werden, wie der Rollkragenpullover in der linken oder die Strümpfe in der rechten Abbildung, so ist eine solche Teilkolorierung ein geeignetes Gestaltungsmittel. Die Kombination von Buntstiften verschiedener Stärken lässt insbesondere die linke Illustration sehr detailliert und ausgearbeitet wirken.

Another interesting way of accentuating an article of clothing is to colour the background. The contrast between the foreground and background draws the viewer's eye to the model and clothing.

Une autre solution intéressante pour mettre en valeur un vêtement consiste à colorier le fond au lieu du vêtement lui-même. Le contraste entre le premier plan et l'arrière-plan attire le regard sur le mannequin et ce qu'elle porte.

Eine interessante Alternative zur Hervorhebung eines Bekleidungsartikels ist die Kolorierung des Hintergrundes an Stelle des Kleidungsstücks selbst. Der Kontrast zwischen Vorder- und Hintergrund lenkt den Blick des Betrachters auf das Model und seine Bekleidung.

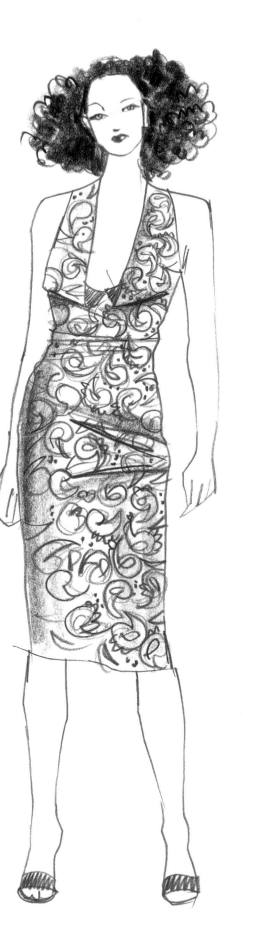

Shadows can be drawn using soft pencils as well as with other pencils. The light falling on this dress with its detailed pattern is suggested by the brighter areas, and the shadows by the darker areas. The intensity of the colour depends on how the pencil is held.

Les ombres sont réalisées au crayon gras comme avec les autres crayons. Sur cette robe au motif très détaillé, la lumière est représentée par les parties plus claires, l'ombre par les parties plus foncées. Les couleurs sont plus ou moins franches selon la manière dont le crayon est tenu.

Schatten werden mit weichen Stiften genauso gezeichnet wie mit anderen Techniken. Der Lichteinfall bei diesem Kleid mit detailliertem Stoffmuster wird durch die helleren Partien angedeutet, der Schatten durch die dunkleren. Je nach dem, wie der Stift gehalten wird, ist die Kolorierung mehr oder weniger kräftig.

If backgrounds like these in these two illustrations are to be smudged, then a soft pencil should be used, held almost perpendicular to the paper in order to fill in the surfaces with colour. By colouring in the entire background in the drawing on the right, the model and its uncoloured clothing are highlighted. In the drawing on the left, the model's tights and shoes are emphasised, as only the upper part of the illustration has a coloured background.

Pour estomper les fonds, comme sur ces deux illustrations, les surfaces correspondantes sont coloriées avec un crayon de couleur gras tenu presque horizontalement. À droite, le fond entièrement colorié fait ressortir le mannequin dont les vêtements sont dépourvus de couleur ; à gauche, les collants et les chaussures du mannequin sont mis en valeur par un fond coloré ne couvrant que le tiers supérieur de l'image.

Sollen Hintergründe wie bei diesen beiden Illustrationen verwischt werden, so wird ein weicher Buntstift fast waagerecht zum Papier angesetzt, um dann die entsprechenden Flächen zu kolorieren. In der rechten Abbildung wird durch den vollkommen farblich gestalteten Hintergrund das Model und seine unkolorierte Kleidung in den Fokus gestellt, während links die Strumpfhose und Schuhe des Models betont werden, da die Illustration nur im oberen Drittel einen farbigen Hintergrund hat.

The alternating use of soft and hard
pencils lends this illustration structure
and depth. All the individual elements of
a drawing do not have to be coloured.
The fact that the colouring here seems
incomplete and extends beyond the
outlines only makes the figure seem that
much more lively.

L'alternance de crayons de couleurs gras
et secs confère plus de structure et de
profondeur à l'illustration dans son
ensemble. Il n'est pas nécessaire de
colorier uniformément les différentes
parties du dessin : un coloriage qui,
comme ici, semble inachevé et déborde
même légèrement, donne plus de vie au
personnage.

Die abwechselnde Verwendung von
weichen und harten Buntstiften verleiht
der Illustration insgesamt Struktur und
Tiefe. Die einzelnen Partien einer
Zeichnung müssen gar nicht vollflächig
ausgemalt werden, denn wenn wie hier
die Kolorierung unvollendet zu sein
scheint und auch noch über die
Konturen hinaus reicht, wirkt die Figur
lebendiger.

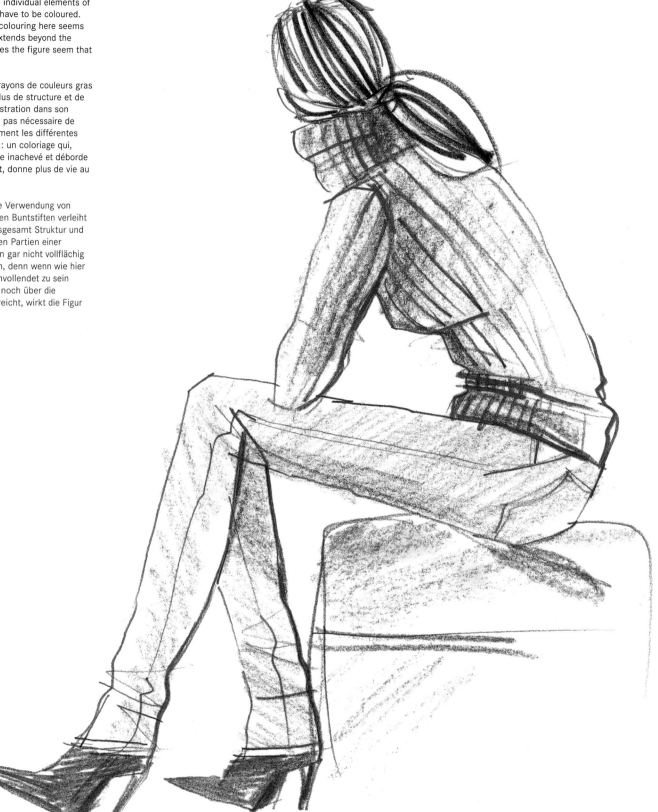

Stark contrasts and accentuations can be created in an illustration by combining two different techniques. Here, coloured pencils have been used for texture, volume and shading, whereas felt-tip pencils have been utilised to render the stockings and shoes.

Pour des contrastes clairs et des accents marqués, on peut associer deux techniques différentes, comme ici les crayons de couleur, utilisés pour représenter la texture, le volume et les ombres de la robe, et les crayons feutres pour les bas et les chaussures.

Klare Kontraste und Akzentuierungen lassen sich bei einer Abbildung erzielen, wenn zwei unterschiedliche Techniken miteinander kombiniert werden. Hier wurden Buntstifte für Textur, Volumen und Schatten des Kleides benutzt, für Strümpfe und Schuhe wurden Faserstifte verwendet.

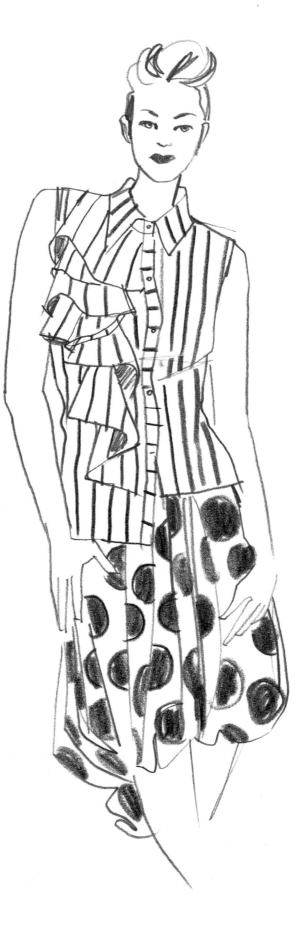

When the pattern of the fabric or different textures have to be conveyed, the artist must be careful to render the volume of the fabric and to show both motion and draping.

Pour représenter le motif d'une étoffe ou des différences de texture, il importe de tenir compte du volume du vêtement pour en rendre correctement le mouvement et le drapé.

Wenn die Muster eines Stoffes oder verschiedene Texturen gezeichnet werden, ist darauf zu achten, dass sie dem Volumen eines Textils entsprechend dargestellt werden und Bewegung sowie Faltenwurf widerspiegeln.

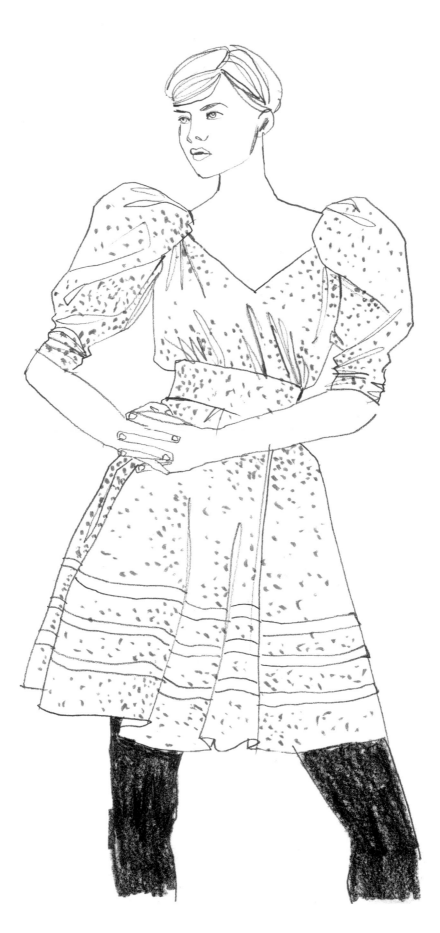

In this illustration of a dress, the three lower stripes on the skirt are not straight, rather they follow the drape of the dress. The parts less illuminated by light are more dappled than those that receive direct light.

Sur cette esquisse de robe, les trois rayures horizontales du bas de la jupe ne sont pas rectilignes mais suivent les plis du tissu. Les zones moins éclairées ont été plus mouchetées que celles en pleine lumière.

In diesem Entwurf eines Kleides verlaufen die drei unteren Rockstreifen nicht geradlinig, sondern folgen dem Faltenwurf. Die vom Licht weniger ausgeleuchteten Partien wurden stärker getüpfelt als die direkt angestrahlten.

Graphite works quite well to render shiny areas, which on this retro black patent-leather jacket are especially well-defined thanks to the contrast with the matte black beret.

Le crayon graphite est idéal pour rendre le chatoiement d'un vêtement, comme cette veste rétro en cuir verni noir, que le contraste avec le béret d'un noir mat fait particulièrement ressortir.

Graphit eignet sich hervorragend zur Darstellung von Glanzlichtern, die bei dieser schwarzen Lacklederjacke im Retro-Look durch den Kontrast zur mattschwarzen Baskenmütze besonders deutlich hervortreten.

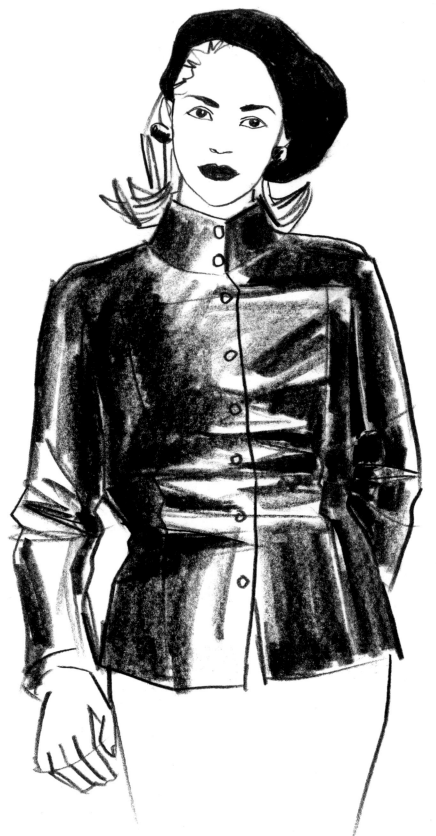

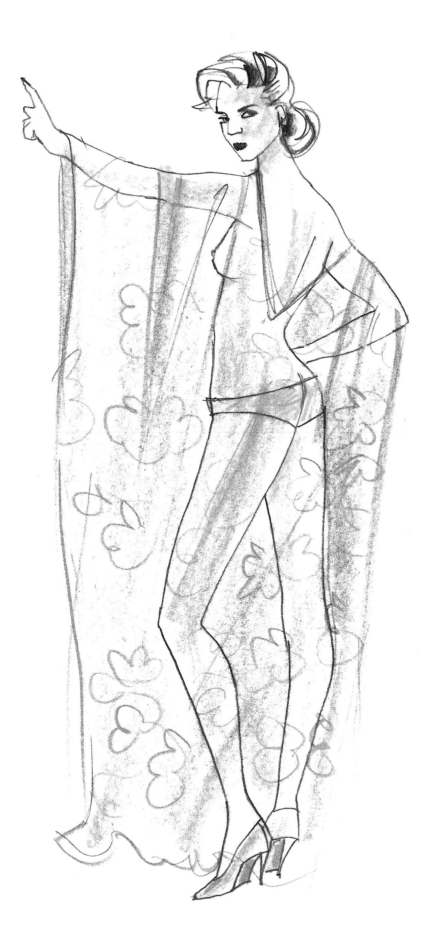

Transparent materials can be skilfully rendered with a soft coloured pencil, which should be held at an angle. The folds of the fabric and outlines have been painstakingly depicted, though the latter have not been shown in full so as to convey the airy swathes of fabric.

Pour représenter les tissus transparents, tenir un crayon de couleur gras le plus incliné possible. Les plis du tissu sont particulièrement mis en valeur, de même que les contours qui ne sont cependant pas continus afin de suggérer l'ampleur et la légèreté de l'étoffe.

Transparente Stoffe lassen sich mit einem weichen Buntstift, der beim Zeichnen möglichst schräg gehalten wird, gut darstellen. Die Stofffalten werden ebenso wie die Konturen stark herausgearbeitet, letztere werden allerdings nicht ganz durchgezogen, um die luftige Weite des Gewebes anzudeuten.

Watercolour pencils are used to make
large-format, no-frills drawings. Here the
figures were traced with the watercolour
pencil and colour was then applied with
a damp brush. The strokes vary
according to the wetness of the brush.

Les crayons aquarelle sont utilisés pour
les dessins grand format sans fioritures.
Ici, le personnage a été d'abord dessiné
au crayon aquarelle, puis la couleur
étalée au pinceau humide. Les
différences de tracé sont obtenues en
humidifiant plus ou moins le pinceau.

Aquarellstifte werden zur Gestaltung
großformatiger, schnörkelloser
Zeichnungen benutzt. Hier wurde die
Figur mit dem Aquarellstift
vorgezeichnet und anschließend die
Farbe mit einem angefeuchteten Pinsel
verstrichen. Die unterschiedliche
Strichführung hängt von der Feuchtigkeit
im Pinsel ab.

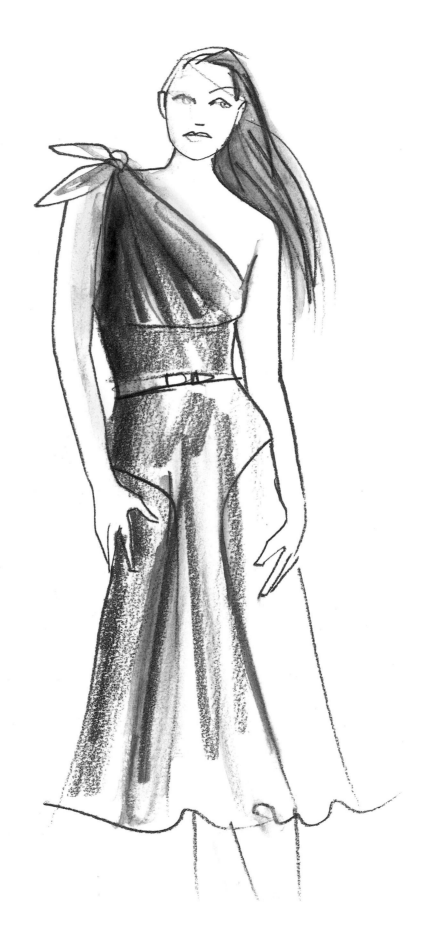

Watercolour pencils are especially well-suited for illustrating light, shadow, volume and all the parts of a drawing that have little or no detail. The cursory yet precise lines make the drawing seem more professional, more distant and more abstract than those using other techniques.

Les crayons aquarelle conviennent tout particulièrement pour rendre l'ombre et la lumière, le volume ou toutes les parties d'un dessin présentant peu ou pas de détails. Le tracé souple et précis fait paraître l'illustration plus sobre, plus froide et plus abstraite.

Aquarellstifte eignen sich ausgezeichnet, um Licht, Schatten, Volumen und alle Teile einer Zeichnung zu illustrieren, die kaum oder gar keine Details aufweisen. Die ebenso lockere wie präzise Linienführung lässt die Abbildung sachlicher, kühler und abstrakter wirken als bei anderen Zeichentechniken.

Here, a balloon skirt made of thick
fabric, a panel skirt and a net-lace skirt
are illustrated. On the right, a flounced
skirt and a pleated skirt have been
depicted. The drawings were all made
with soft pencils, which can be used for
virtually any kind of fabric, although they
are not well-suited for rendering details.

Sur cette page, une jupe ballon en tissu
épais, une jupe à pans et une jupe en
tulle ; à droite une jupe à volants et une
jupe plissée. Les dessins ont tous été
réalisés avec des crayons gras : on peut
s'en servir pour représenter presque
tous les tissus, mais ils ne conviennent
guère pour mettre en valeur des détails.

Hier sieht man einen Ballonrock aus
dickem Stoff, einen Bahnen- und einen
Tüllrock, die rechte Seite zeigt einen
Volant- und einen Plisseerock. Die
Entwürfe wurden alle mit weichen
Stiften gezeichnet, die zur Darstellung
beinahe jedes Stoffes benutzt werden
können, allerdings zur Herausarbeitung
von Einzelheiten kaum geeignet sind

COLLAGE

LE COLLAGE / COLLAGE

The French term "collage" was originally used only to refer to paintings, but it was gradually applied to other kinds of artistic and visual compositions consisting of different materials, including photographs, pieces of leather or fur, newspaper cut-outs, fabric and other materials. This final chapter focuses on collage and other techniques used to create original illustrations.

Le terme collage, d'abord uniquement utilisé en peinture, en est venu peu à peu à désigner toutes les compositions artistiques ou visuelles formées de différents éléments : photographies, cuir, fourrure, coupures de journaux, tissus ou autres matériaux. Notre dernier chapitre présente cette technique qui permet de créer des illustrations particulièrement originales.

Der französische Begriff collage wurde ursprünglich nur für Werke der Malerei verwendet, nach und nach aber auch auf alle künstlerischen bzw. visuellen Kompositionen übertragen, die aus unterschiedlichen Elementen, wie Fotografien, Leder- oder Pelzstückchen, Zeitungsausschnitten, Stoffen und ähnlichen Materialien, bestehen. Dieses letzte Kapitel zeigt diese und andere Techniken, mit denen sich originelle Illustrationen schaffen lassen.

The overlapping coloured rectangles of different sizes in this figure reflect a design concept that attempts to bring together various kinds of colour components. Thick black, felt-tip outlines lend this unusual illustration additional expressive force.

La superposition de carreaux de tailles et couleurs différentes sur ce personnage illustre un concept stylistique qui cherche à associer diverses composantes colorées. Les contours épais au feutre noir donnent encore plus d'expressivité à cette illustration insolite.

Die Überlagerung verschieden großer farbiger Rechtecke in dieser Figur spiegelt ein Designkonzept wider, das unterschiedliche Farbkomponenten miteinander zu verbinden versucht. Dicke schwarze Faserstift-Konturen verleihen dieser ungewöhnlichen Illustration zusätzlich Ausdruckskraft.

With some imagination, fashion and design trends can be both simply and accurately depicted, such as the fabric patterns here. The illustration appears modern and up-to-date thanks to the use of a ballpoint pen, still a relatively new writing and drawing tool.

Il suffit d'un peu d'imagination pour illustrer les tendances de la mode ou du design avec simplicité et justesse, comme ici à l'aide de quelques motifs de tissus. L'ensemble donne une impression de modernité et d'actualité grâce au choix du stylo à bille, un outil d'écriture et de dessin encore assez récent.

Mit etwas Fantasie lassen sich Mode- oder Designtrends ebenso einfach wie treffend darstellen, wie hier am Beispiel einiger Stoffmuster gezeigt wird. Die Illustration wirkt modern und aktuell durch ihre Ausführung mit einem Kugelschreiber, einem noch relativ jungen Schreib- und Zeichengerät.

If a fashion illustration is to look completely realistic, articles of clothing can be cut out of a photograph and added to the drawing of a model. This illustration makes an unusual impression on observers, but is nevertheless quite lively and dynamic.

Pour une illustration de mode parfaitement réaliste, découper un vêtement d'une photographie et dessiner librement le mannequin tout autour. L'effet produit est inhabituel, mais aussi vivant et dynamique.

Soll eine Modeillustration absolut realistisch sein, schneidet man ein Kleidungsstück aus einer Fotografie aus und zeichnet das Model frei hinzu. Die Abbildung wirkt auf den Betrachter ungewöhnlich, aber sehr lebendig und dynamisch.

Here it is the model who looks extremely authentic and almost photographically real, while the clothes are stark white and without outlines. The missing outlines are unconsciously added by the observer, who only vaguely perceives them.

Ici, c'est le mannequin qui semble véritablement authentique, presque aussi réaliste que sur une photo, tandis que le vêtement a été entièrement laissé en blanc et sans contours : l'observateur « devine » la silhouette et ajoute inconsciemment les contours manquants.

Hier ist es das Model, das äußerst authentisch, fast fotorealistisch gezeichnet wurde, während die Kleidung vollständig weiß und konturenlos bleibt. Die fehlenden Konturen werden vom Betrachter, der den Umriss erahnt, unbewusst hinzugefügt.

An illustration can also seem quite realistic if a model is cut out of a photograph and the desired article of clothing drawn onto the figure. In choosing a photograph, the artist must remember that the size and shape of the article of clothing must match the model's pose and expression.

Pour une illustration réaliste, on peut aussi découper une photographie de mannequin et dessiner le vêtement voulu par-dessus. Au moment de choisir la photographie, penser à adapter la taille et la forme du vêtement à la pose et à l'expression du personnage.

Realistisch wirkt eine Illustration auch, wenn das Model aus einer Fotografie ausgeschnitten und das gewünschte Kleidungsstück anschließend auf die Figur gezeichnet wird. Bei der Auswahl der Fotografie ist zu bedenken, dass die Maße und Form des Kleidungsstücks zu Pose und Ausdruck der Trägerin passen.

These three drafts within a single
illustration show how the collage
technique can be imaginatively applied
using photographs and other visual
elements. This picture, relatively unusual
for a fashion illustration, focuses
attention on the clothing worn by the
models.

Ces trois esquisses montrent comment
utiliser de manière très imaginative la
technique du collage à partir d'éléments
photographiques et graphiques. Cette
composition plutôt inhabituelle dans le
domaine de la mode attire le regard sur
les robes que présentent les mannequins.

Diese drei Entwürfe in ein und derselben
Illustration zeigen, wie sich die Collage-
technik aus fotografischen und zeich-
nerischen Elementen fantasievoll
anwenden lässt. Die für Modeabbildungen
eher ungewöhnliche Gestaltung fokussiert
den Blick des Betrachters auf die von den
Models präsentierten Kleider.

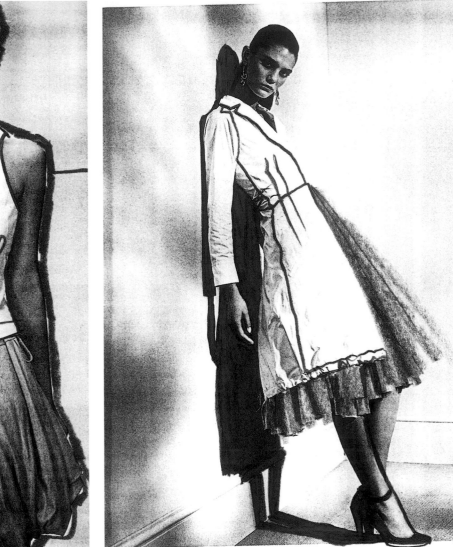

The technique of colouring photographs, as can be seen in these two illustrations, allows the fashion designer to alter or modify a design. Since a photograph can always be reproduced and modified, it is possible to experiment with different styles and details, and to develop a good sense of design through this creative process.

Le coloriage de photographies, comme sur ces deux illustrations, donne au créateur la possibilité de modifier ou de transformer une esquisse. En effet, une photographie peut toujours être imprimée et retravaillée, ce qui permet d'essayer différents styles ou détails et de développer un sens pour le design à travers ce processus créatif.

Die Übermalung von Fotografien, wie sie in diesen beiden Abbildungen gezeigt wird, gibt dem Modedesigner die Möglichkeit, einen Entwurf zu verändern oder abzuwandeln. Da sich eine Fotografie immer wieder ausdrucken und neu bearbeiten lässt, kann man verschiedene Stile oder Einzelheiten ausprobieren und durch diesen kreativen Prozess ein gutes Gefühl für ein Design entwickeln.

A black-and-white photograph can be very subtly altered. In this illustration, the model's hair and accessories were coloured over and a pattern was added to the sweater. This technique also makes it possible to include new backgrounds, new articles of clothing and/or new details.

Une manière très subtile de modifier un tirage en noir et blanc : les cheveux et les accessoires du mannequin ont été coloriés et son pull-over orné de motifs. Cette technique permet aussi d'ajouter de nouveaux fonds, vêtements ou détails.

Eine Schwarzweißaufnahme lässt sich sehr subtil verändern. In dieser Illustration wurden das Haar und die Accessoires des Models übermalt und der Pullover mit einem Muster versehen. Diese Technik erlaubt es auch, neue Hintergründe, Kleidungsstücke oder Details einzufügen.

This illustration shows a variation of the collage technique. Layering papers with different structures and colours serves to elucidate the character and nature of the design. Usually at least three different kinds of paper are used: one for the background, one for the model and one for the clothing.

Cette esquisse illustre une variante du collage : la superposition de papiers de différentes structures et couleurs pour mettre en évidence le caractère et le style d'une création. En général, on utilise au moins trois papiers distincts : un pour le fond, un pour le mannequin et un pour le vêtement.

Diese Illustration zeigt eine Variante der Collage, das Übereinanderschichten von Papieren unterschiedlicher Struktur und Farbe, um Charakter und Art eines Designs zu verdeutlichen. Es werden zumeist mindestens drei verschiedene Papiere verwendet, jeweils eins für den Hintergrund, das Model und die Kleidung.

Grey cardboard was selected for the background of this collage. The figure was made from beige-coloured paper, the dress from transparent paper and the cloud-shaped embroidery was created from nonwoven fabric.

Sur ce collage, un carton gris a été choisi en guise de fond et le personnage découpé dans du papier beige. La robe est en papier transparent et les nuages brodés ont été réalisés avec du papier non tissé.

Ein grauer Karton wurde bei dieser Collage für den Hintergrund ausgewählt. Die Figur besteht aus einem beigefarbenen Papier, das Kleid aus Transparentpapier, und die wolkenförmige Bestickung wurde aus Vliesstoff gefertigt.